W9-ADK-483

PABLO

THE LAST YEARS

PICASSO

F.W. Olin College Library

Translation from the Spanish to the French,
presentation, and notes by Alberto Miguel Montañés
English translation (from the French) by Luke Sandford

© Assouline Publishing
601 West 26th Street, 18th Floor
New York, NY 10001, USA
www.assouline.com

ISBN : 2 84323 613 4

Printing by RR Donnelley (United States)

All rights reserved.
No part of this publication may be reproduced, stored
in a retrieval system, or transmitted in any form
or by any means, electronic, mechanical, photocopying,
recording, or otherwise, without prior consent from the publisher.

Mariano Miguel Montañés

PABLO

THE LAST YEARS

PICASSO

Foreword by Olivier Widmaier Picasso
Introduction by Alberto Miguel Montañés

ASSOULINE

The twentieth century, in the person
of a 92-year-old man, ends
27 years before the conventional date.

René Char

Contents

I have often said that Pablo Picasso's life began for me on the day he died: April 8, 1973. Before that, my grandfather did not exist, not in my dreams, and not in the "real" world. He appeared only on the walls of our home, quite present and quite abstract all at once. Nevertheless, on that April morning, my world changed. In the space of a few days, I received answers to questions I'd never bothered to ask before. I had become a boy with a large puzzle to complete, and many of the pieces were still missing. I did, however, have something to go on: I was sure I had a grandfather, a grandmother (Picasso's muse, Marie-Thérèse), and my mother, Maya.

So I set out to complete the puzzle.

In the end, it took me thirty years to identify and comprehend this fragmented, "Cubist" universe, if you will, with Picasso as its sun-like central figure. Thanks to the artworks that hung on our walls, we had a tiny stake in his timelessness. Yet we knew nothing of the day-to-day life he led in his own home.

Pablo Picasso, The Last Years *represents the final piece of this puzzle. I have met many people who knew my grandfather. Although they have all sought to share their recollections of him with me, perhaps no one has depicted his life so fittingly and accurately as Mariano Miguel Montañes, his personal secretary and an unimpeachable witness to his final years—a*

crucial period that warrants full recognition. My grandfather had decided to retire to Mougins, a tiny village on the outskirts of Cannes, and he selected as his assistant a man whom everyone came to know simply as Miguel, in much the same way that Picasso was known simply as Picasso. A singular honor!

Until now, I had pictured Mougins in the blended colors of twilight, much like the flamboyant and powerful portraits of the mousquetaires *or of Jacqueline, his final muse and wife. These were my grandfather's twilight years as well, and time was of the essence. With Jacqueline standing guard, Miguel took care of everything he could. Although these are the years that are nearest to our own time, they have been the subject of much misunderstanding—a missing link in the chain, obscured behind an imposing and, by some accounts, insurmountable barrier.*

Today, thanks to Miguel's Journal and to his son Alberto, who has worked so hard to bring its treasures to light, the silence surrounding my grandfather's final years has been dispelled. The voices and the sounds, the awkward and unspoken moments—even the fragrant scents of the garden—come rushing back to life in this daily and sometimes hourly account of my grandfather's final years. The past becomes present.

Thank you, Miguel: I've completed the puzzle!

Olivier Widmaier Picasso

Pablo Picasso died on April 8, 1973, a few months shy of his ninety-second birthday. His final years were particularly important to his life's œuvre. Driven by an acute awareness of the passage of time, drawing incessantly on his boundless imagination, and in full possession of his creative powers, he built upon his extraordinarily productive body of work while continuing to show great inventiveness as a painter and printmaker. More so than in any other period of Picasso's life, human considerations lay at the core of his creativity. At times, aspects of this same humanity would emerge in a riotous profusion of portraits, new forms, and colors.

There was certainly something superhuman about Picasso the artist. Nevertheless, those lucky enough to make his acquaintance and to spend time with him (I had the privilege of meeting him when I was 20) came away struck by the man, by his simplicity, by his kindness to others, and by his wonderfully mischievous sense of humor.

At the same time, if one observed the astonishing sweep of his gaze and his intense concentration, it became clear that Picasso's creativity shone through at every single moment.

My father saw the Maestro constantly from May 1968 until Picasso's death. He reported for work every day at Notre-Dame-de-Vie, Picasso's residence in Mougins, a village high in the countryside north of Cannes. As Picasso's close friend, my father served as his personal secretary and sometime confidant. His Journal recounts some of the events—important ones as well as trivial— that marked Picasso's final years, which he spent together with his wife Jacqueline.

Those close to Picasso called my father by his familiar name, Miguel (his full name was Mariano Miguel Montañés). Miguel and Pablo first met in 1945, in the wake of the dramatic events of the Spanish Civil War (1936–39) and the Second World War (1939–45). From the outset, Picasso supported his Republican compatriots. His painting *Guernica* is an outstanding example of this support, both as an artistic creation and in symbolic terms. Many Spanish nationals took refuge in France in 1939 and went on to play an active role in the French Resistance. But when the war ended and Franco's regime still clung to power, the refugees could not simply return home, because once home they faced the unhappy prospects of either death by firing squad or a long jail sentence. With

no money and no work, some refugees found themselves in a predicament when the Liberation finally came. Out of generosity and the force of his convictions, Picasso provided substantial assistance to the Spanish refugees, including donations of money and artworks. My father's role in coordinating the relief efforts meant that he was in regular contact with the painter. It was under those conditions that the pair struck up a friendship.

My father was born on May 29, 1913, in the city of Santander, in northern Spain. When the Civil War broke out in 1936, he was working at one of Barcelona's largest bookstores. A few months before, he had even considered buying his own store, in partnership with a friend, although subsequent events were to dictate otherwise. As my father saw it, the military uprising that had begun in Morocco posed a grave threat to the Spanish Republic. He therefore reported to Madrid to enlist with the Republican army.

I possess no documents or detailed accounts of my father's day-to-day relationship with Picasso in the period immediately following the Liberation. At that time, Picasso's childhood friend Jaime Sabartés, whose name crops up several times in the Journal, was working

as Picasso's biographer and secretary. My father ended up working closely with Sabartés, who went on to become one of my father's and our family's closest friends. Based on my father's recollections and on his correspondence with Picasso, Miguel apparently dealt with logistical and organizational matters. He also directed the flow of visitors to Picasso's studio on the Rue des Grands-Augustins in Paris and continued to coordinate efforts with the organizations assisting the Spanish refugees. Picasso subsequently relocated to the Côte d'Azur and made his permanent home there, while, instead of going with Picasso, my father took a regular job with a company in Paris. As a result, Picasso and my father saw each other less often, and did not see each other at all from 1959 until 1968. Sabartés and my father met frequently during that period, however, and it was through Sabartés that my father kept in touch with Picasso. On several occasions, Picasso and Jacqueline expressed hopes that my father would move to Cannes to oversee operations at Notre-Dame-de-Vie. After Sabartés died on February 13, 1968, my parents moved into the Villa Californie in Cannes. My father took up his position as Picasso's personal secretary later that spring.

Ostensibly, one of the reasons my father moved to Cannes was that Picasso's library needed reorganizing. But, to the best of my knowledge my father never concerned himself with such tasks, and if he did, it was only occasionally. As for the rest of Miguel's job description, Picasso told him upon his arrival: "I can't give you all the details because I don't quite know what a secretary is supposed to do. If I knew, I'd do it myself. But I'm sure you'll figure out what needs to be done." My father interpreted Picasso's comments to mean that his duties would be numerous and vague. He would have to be adaptable, staying close at hand when he was needed and remaining invisible when he was not.

In reality, my father's duties were indeed varied but quite down-to-earth. They included administrative tasks, such as sorting the mail, responding to enquiries, supervising the staff, paying bills, preparing tax returns, and taking care of certain legal matters. He also handled phone calls, met with on-site visitors, and oversaw the artist's logistical arrangements (exhibitions, catalogues, and various projects). My father's role in Pablo and Jacqueline's daily life was as a trusted confidant and friend, and he was often present when the Picassos' many

friends and acquaintances stopped by to visit. In my father's mind, the most important aspect of his job was watching out for the artist's welfare while maintaining peace and quiet, thereby allowing Picasso to work and devote himself to his art. Miguel also helped Jacqueline, whose devotion to and affection for her husband were quite remarkable in her own right. After Picasso's death, my father remained in Jacqueline's employ for a number of years. He carried out his duties and took part in the complex task of administering Picasso's estate. In September 1977 he returned to Paris and began his retirement. During that time, he worked on his wartime memoirs, a task that kept him occupied during his final years, and traveled frequently to Spain.

Regarding the Journal itself, I should point out that my father never had any literary pretensions. I believe that he wrote primarily for himself. Writing was a way for him to examine his life, to sift through his memories and to reflect on them. The idea of keeping a journal came to him quite naturally. He simply wanted to record, for his own use, a general account of his day-to-day contact with one of the most important artists of the twentieth century. As soon as he arrived in Mougins, my father began

jotting down his observations in a notebook, together with Picasso's remarks and descriptions of various visitors. He also included his reflections on the time he spent with the Maestro in the years after the war. Even though he never intended to publish the Journal, he was clearly careful not to speak his mind entirely. Indeed, discretion was one of my father's watchwords. Throughout the Journal, he chooses to stay in the background since he is not the primary focus of the narrative. Nevertheless, he is still present. His unique way of observing and recording his impressions affords us a discreet glimpse into his own character. The Journal taught me a lot about my father, in particular the nature of his friendship with Picasso, a man he truly admired. Indeed, I should point out that my father was not much given to idolizing others. His life experiences had left him highly cautious, even skeptical, in that regard. Picasso, however, was the sole exception to this rule, not because my father worshiped him as a hero, but because he felt deep admiration and affection for him.

My father first mentioned the Journal to me shortly after he began keeping it. He said that Picasso had walked into his office one day and must have realized that my father was writing about him. Yet the artist said

nothing. My father thought he might disapprove if a witness to his life decided to record his experiences. He discontinued the Journal on January 8, 1969. Although he explained his decision to me, I was disappointed at the time because I knew how historically significant his story was. Still, my father continued to pick up his pen from time to time to describe certain events in Picasso's life and in their relationship. Today I believe we are truly fortunate to possess this account of Picasso's final years—a lesser-known chapter of Picasso's life. That is why I decided to publish the Journal, more than thirty years after the events.

The Journal is based on my father's notebook and various loose pages. Everything is dated, except for one anecdote, and in that particular case, the year itself is not in doubt. The manuscript consisted of one long text, in Spanish, which was never altered or tidied up. In it, my father records observations and fragments of conversations. He also voices his opinions and describes his various activities. Everything centers on Pablo Picasso and takes place at Notre-Dame-de-Vie. With each new episode,[1] an impression of intimacy and proximity to the painter emerges. Although the Journal provides only a

partial picture of Picasso's last years, for the aforementioned reasons, my father was a direct participant, endowed with keen powers of observation, and he knew Picasso well.

In its own special way, the Journal also serves to illustrate the human comedy. In these pages, Picasso is often bombarded with requests, and he wields immense power. If he decides to present someone with a drawing or to collaborate on a book or film project based on his life or work, the recipients may well reap untold benefits. We therefore see a number of solicitations wrapped up in the guise of friendship. Even so, Picasso also has a number of genuine friends and admirers who visit, and it is wonderful to relive such moments. As the months and years go by, Picasso's health begins to falter, and my father, together with Jacqueline and the people around her, grow worried and the Journal evolves into a terse reflection on the two men's friendship.

Pablo Picasso was a force unto himself, creative and humanistic, godlike yet mortal. More than anyone, he knew the true value of time. In his final years, he worked without respite in his hilltop studios at Notre-Dame-de-Vie. Seated at his table in the living room, hunched over

a copper plate, holding his engraver's chisel, we can see Picasso hard at work, breathing life into the myriad characters of a never-ending story. On other occasions, night has fallen and the artist is tense, a picture of concentration, with tubes of paint strewn at his feet as he does battle with the canvas again, illuminated by floodlights. Perhaps this time the taut white surface will end up representing a man smoking a pipe, or a woman with a bird, or maybe a lovers' kiss. Although Picasso had nothing left to prove, he continued to paint and to engrave. And the fruits of his labors, which he showed first to his astonished friends and then to the larger audiences who see his work on display at exhibitions in Paris and Chicago and at the Palais des Papes in Avignon are infinitely beautiful and infinitely moving. This Journal provides us with important insights into the final years of this remarkable man—so incredibly creative and so genuinely human.

Alberto Miguel Montañés

1- *I have always regretted that a certain meeting with Mstislav Rostropovich was not recorded in this Journal. My father kept a wonderful souvenir of it. Rostropovich had transcribed the notes of the songs of the Spanish Republic, which my father had hummed, before brilliantly interpreting several variations of them on his cello. The painter's grandson, Olivier Widmaier Picasso, has related Rostropovich's recollection of his relationship with his grandfather in a recent biography:* Picasso: The Real Family Story, *Prestel, 2004.*

1968

June 13

We arrived at Notre-Dame-de-Vie shortly after noon yesterday. I spoke my name into the intercom outside the entrance gate, and the gate swung open. Jacqueline was waiting for us on the front doorstep of their large Provençal-style home. Her greeting was both simple and kind. "Pablo is still up in his room. He's doing great, working harder than ever, and never feels tired," she said.

As I looked at Jacqueline, I found myself thinking of all the occasions she has sat as Picasso's model. To tell the truth, "model" isn't quite the right word. Drawing on his extraordinary powers of memory, Picasso will take careful note of features and forms. Then one fine day, the fruits of his observations are revealed on the canvas or drawing paper. The contours he traces may form a portrait that is far removed from reality, or the pencil or brush may end up revealing an essential truth.

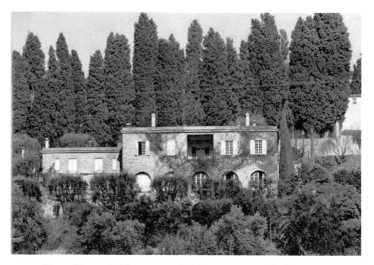

Notre-Dame-de-Vie, surrounded by cypresses and olive trees,
overlooking the bay of Cannes.

We enter the "dining" room, but aside from the
table in the middle, nothing indicates that any meals are
served here. The couch, chairs, and other furnishings
are covered with various paintings, drawings, books,
catalogues, papers, letters, leaflets, newspapers, and
magazines. These range from valuable objets d'art to
simple curios. There is also a television set, together
with a turtledove in a cage and heaps of clothing. Each
of these items has a role to play in this scene of petrified,
almost sacred disorder. No one would dare touch a thing;
only the "Maestro" is allowed to adjust the décor, adding
new canvases and prints, more books and letters, addi-

tional piles of clothes, forming layers akin to geolo-gical strata. In the final analysis, this is a tiny slice of the uni-verse Picasso has created for his own use.

Except for one short visit last winter, I haven't seen Picasso in nine years. He seems virtually unchanged: ramrod-straight posture, eyes that take in everything, and an abiding air of kindness. In our twenty-three years of friendship, I have managed to keep up with his life and work, whether I was nearby or far away.

Picasso greets us warmly and, after the customary exchange of greetings, he mentions my position: "I can't give you all the details because I don't quite know what a secretary is supposed to do. If I knew, I'd do it myself. But I'm sure you'll figure out what needs to be done."

As I attempt to determine what this actually means, I realize my role will be multifaceted and quite imprecise. I will have to be adaptable, every minute, every hour, every day. I will have to be nearby when I'm needed and invisible when I'm not.

June 14

As I have often observed Picasso at close quarters, I know all about his enormous appetite for work. For some time, he has been focusing almost all of his energies on, or so it appears. He must have done a lot of painting last winter. I remember that during my short visit a few months ago, Jacqueline showed me a few of his most recent paintings. One in particular made a deep impression on me. Judging by the date inscribed on it, it must have been completed the previous day. It showed two nudes, both standing, with one looking downward. A series of lines in the most fantastic shade of green completed the scene. Although Jacqueline confirmed that the painting was still there, I haven't seen it since.

Picasso's printer—or should I say printers?—are the two Crommelynck brothers, Piero and Aldo. They constructed a tiny makeshift workshop in a house in Mougins,¹ where the Maestro has them permanently on call. Some days Picasso sleeps until almost noon and works during the afternoon and evening, often continuing until dawn. When he's finished his engravings, he calls up the Crommelyncks. One of the brothers stops by to pick up the plates, which he uses to make an initial run of two prints. If Picasso is dissatisfied with the

results, or if he gets carried away by his eternal need to take things further and to seek new effects, he'll resume work on the plate. This may lead to a second or third version, sometimes more. Picasso's œuvre contains myriad examples of such variations on a theme, produced by making changes to existing plates.

I told Picasso about a print I have at home, which he dedicated to Sabartés in 1946.² It depicts a red shellfish on a table covered with a blue-and-white checked table-cloth, illuminated by a yellow lantern.

In the past, Picasso often concentrated on still lifes, although this genre seems to hold less interest for him nowadays. His current prints tend to feature circus performers, or seventeenth-century knights and ladies, or even the ever-present Celestina,³ accompanied by a naïve-looking naked young woman standing next to her, as exposed as an item in a shop window. His cast of characters likely stems from the same source. In fact, the richly adorned princess and the gallant knight bowing down before her, hat in hand, may once have been humble circus or theater folk, to whom the artist's creative fantasy has assigned the trappings of nobility.

It is quite apparent that Picasso has intensely lived

out the scenes in his. They are all chapters of the same story—a story the author recounted to himself before undertaking a translation into his plastic idiom.

June 15

I have quickly come to realize that Notre-Dame-de-Vie, or should I say its most famous resident, has become a worldwide point of interest—but this hardly comes as a surprise.

The mail Picasso receives every day is impressive. Letters arrive from around the world, written by people representing a wide range of backgrounds. Most of them express enthusiasm and admiration. Some view Picasso as a symbol of their highest aspirations: peace, for those trapped in war zones; and freedom, for those suffering under the yoke of oppression.

My job is to sift through this shapeless mass to pick out anything that might interest Picasso, such as messages from friends or references to problems with his work.

Some people request autographs or photos. Others don real or imagined beggar's rags before asking for money. Another category of mendicants includes people who seem dazed or envious in the face of so much glory.

One might request an etching to accompany a collection of poetry—still unpublished, of course. Another might be seeking some kind of recommendation. Almost everyone asks for something.

For all of these reasons, it is physically impossible to respond to each letter. Picasso, who tends to favor extreme solutions, solved this problem long ago: he never responds to anyone.

June 16

One of my central concerns is to protect Picasso from the crush of visitors set to invade his home at any moment. Picasso is highly sociable, and he always enjoys getting together with his friends. He also has a deep-seated curiosity about people, ideas, and things. His number one priority, however, is his work. Nevertheless, he knows so many people, and so many people ring his doorbell for one reason or another, that he's obliged to welcome multiple visitors nearly every day.

Today I'd like to talk about the visit of Gustavo Gili and his wife, Ana María.

Gustavo Gili is a publisher from Barcelona who has overseen the Spanish publication and distribution of several books on Picasso. In addition to their business

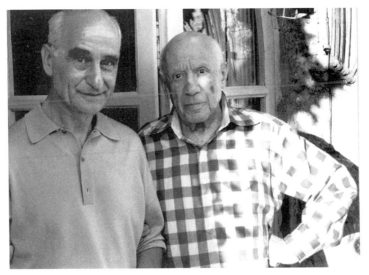

Mariano Miguel Montañés and Pablo Picasso.

relationship, the two families are on very good terms, and their friendship is a long-standing one. Picasso was well acquainted with Gustavo's father, who planned to bring out a deluxe edition of Pepe Hillo's *Tauromaquia*, or *The Art of Bullfighting*,[4] featuring a series of original prints by Picasso. The Second World War put those plans on hold, and Gustavo ended up completing the project himself several years later.

Gili is currently preparing another special deluxe edition in which both the illustrations and the text are by Picasso.

Although Picasso has named the work *The Burial of*

the Count of Orgaz,[5] it would be pointless to look for even the slightest connection with El Greco's famous painting, whether in the text or in the illustrations.

It is a prose text, written without punctuation and flouting the most basic rules of grammar. Indeed, it would also be pointless to seek any narrative thread. The text is merely a series of sentences and descriptions. I can't be any more precise than that! Yet there is so much inventiveness, color, and power in those few pages that the reader will at least be forced to recognize Picasso's inexhaustible genius.

To expand on this notion a little, the reader will soon realize that each brief description relates to a graphic or pictorial work. That is because in this instance, Picasso, who never has enough time to translate every idea his imagination conjures up, turned to the realm of literature to express ideas that might have otherwise disappeared into the dark abyss of oblivion.

We are gathered in the dining room, which also serves as a studio and living room. Picasso shows us some of his most recent works, a privilege he grants to only his closest associates. There is an agenda, however, to Gili's visit. He arrived bearing a set of proofs, and he launches into a long description of the new book.

After beating around the bush a little, he discloses the real reason for his visit. Some of the etchings selected on a previous occasion—three, to be precise—are a little too risqué. He asks if Picasso would mind choosing different ones to replace them.

Picasso's first reaction is to treat the request as a joke: "Eroticism? Sex? There must be some misunderstanding. These are innocent scenes. Mark my words: the couple who seem to be making love are actually performing wrestling holds."

Gili points out that because Spanish censorship is so strict, he could face legal action. Upon hearing this, Picasso grows serious: "My work must be accepted as is, unmutilated. Any risks must be accepted. A man is always answerable for his actions."

Gili does not press the point. He knows Picasso and is well aware that he would never allow his work to be disfigured. The book will come out exactly as planned.

People know that Picasso is a tireless enemy of hypocrisy in all of its forms. Moreover, hasn't the naked human body been a traditional subject of study and a source of artistic inspiration, much like love in its most intimate forms?

June 25

On several occasions, Jacqueline has mentioned her friend Margaret Silberman, an American. Margaret is terribly ill and has been informed by her doctor that her situation is hopeless. At 55, she's still relatively young. Although she knows the end is drawing inexorably near, she never refers to her illness. She continues to travel and to see her friends. She is currently staying in Cannes.

Margaret calls the Maestro "Monseñor." Picasso, who loves puns and is quick to see poetic connections, calls her "Margarita de Plata."

Picasso often grows furious at the mention of visitors. Today, however, he sets his work aside and lavishes his attention on Margaret. I quickly notice that she writes in a tiny notebook when speaking with Jacqueline or Pablo.

Margaret formerly owned a gallery in New York, which was devoted exclusively to Picasso, I believe. Now she makes the rounds of the exhibitions and museums. At one point, she and I were alone, so I took the opportunity to ask her if she was working on a book about Picasso.

"I'm not really a writer," she said. "And I don't have the strength to complete such an important project.

To tell you the truth, I feel passionately about art and I've been lucky in my life to have known numerous painters and sculptors and to have compiled an extensive collection of documents. So now I set down my observations using a tape recorder. But I also intend to show Jacqueline's admirable devotion to Picasso. She's an intelligent and sensitive woman. I want to bring to light everything she represents in Picasso's life and work, so that her contribution is never forgotten."

As Margaret was getting ready to leave, Picasso presented her with a book of reproductions of his works. He inserted a dedication for her that included a tiny drawing. The inscription read: "For Margarita de Plata, who is also made of gold."

September 19

Georges Bloch stopped by today. I first heard his name years ago. I know he's a collector and is acquiring all of Picasso's prints. I also know he is highly knowledgeable about Picasso's graphic œuvre. He recently organized an exhibition of Picasso's etchings and lithographs at the Zurich Museum of Fine Arts. The exhibition was particularly significant and featured 1,400 of Picasso's works. Bloch not only lent out his collection—

everyone knows that collectors don't like to part with their treasures—he also managed to produce a very important catalogue, notable for the number of works listed and the accuracy of the information.

This was Picasso and Bloch's second meeting. Picasso welcomed him as a friend and showed him his latest prints. As Bloch was leaving, Picasso presented him with a deluxe edition of one of his books. He included a dedication and a drawing. Bloch was delighted.

September 20

Sabartés recalls[6] that Picasso was significantly influenced by an 1898 visit to Horta del Ebro,[7] where he stayed at the home of his friend Manuel Pallarès. Picasso had been sick. Not only did he recover, but the fresh air and the contact with people from the countryside opened his eyes to a brand-new world. Picasso often liked to use imagery when he spoke, and he was fond of saying, "Everything I know, I learned in Horta." One of his most important paintings is *Factory at Horta del Ebro* (1909).

Although, I've never met Manuel Pallarès, his name is very familiar to me. During many of my conversations

with Sabartés about Picasso's years in Catalonia, Sabartés often mentioned Pallarès, Picasso's lifelong companion. Picasso had also mentioned Pallarès to me. When Pallarès's son called up this morning to say that he and his father were in Cannes, I knew I would finally get the opportunity to meet one of Picasso's few remaining childhood friends.

I met the father and son that afternoon when I arrived at Notre-Dame-de-Vie. They are a bit on the strange side. They're on vacation and staying on the Côte d'Azur for a few days. Pallarès *père* must be over 90, and his son must be at least 50. They're traveling around the region, spending one day in Nice, one day in Monte-Carlo, and so on.

Pallarès *père* maintains a very straight posture and is truly devoted to his old friend Picasso. As he looked over the latest prints, he kept exclaiming, "You work so hard!" Picasso treats him with great affection. Every day at lunchtime, Picasso's chauffeur drives down to Cannes in the Lincoln to pick up the two men at their hotel. The son is a confirmed bachelor. He takes such good care of his father and is so attentive to him that, seeing them together, I found myself thinking that their roles had been reversed: Pallarès *fils* is now a "father" to his own father.

September 30

I first met Monsieur and Madame Zervos in Picasso's studio on the Rue des Grands-Augustins in Paris in the 1940s. They run *Les Cahiers d'Art*, which, to my knowledge, is the only publishing house that has brought out Picasso's works in their entirety, aside from his graphic œuvre. Some twenty volumes of paintings and drawings have appeared to date. Given the size and significance of these volumes, not to mention the fact that Picasso's works were photographed in his various studios, they are particularly valuable research tools.

The couple is spending the month of September in Cannes. Jacqueline sees them every morning on the beach. Monsieur Zervos has cardiac problems and recently had a heart attack. Fortunately, he made a speedy recovery. Always eager to help her friends, Jacqueline made sure he was attended to by Dr. Stéhelin, Picasso's personal physician. Zervos has to watch what he eats very carefully. Since hoteliers are not nutrition experts, Jacqueline brings over doctor-prescribed foods to Zervos in his hotel room every day.

The couple stopped by Notre-Dame-de-Vie yesterday to say goodbye. They're driving back to Paris tomorrow. Since Picasso likes visitors, he insisted that they extend

their stay in Cannes. He then asked Zervos, "Would you like to see the etchings?"

It must have been close to 5:00 p.m. when we set out a portfolio on the seat of a swing, which served as a makeshift table. The Zervoses were sitting next to Jacqueline and Pablo. I flipped through the prints as they looked on. After we'd finished the first set, we went on to the next. At seven o'clock, I called my wife to tell her I was going to be a little late. We kept on going. With each new set, Picasso asked, "Aren't you getting tired?"

"No, not at all. I'm feeling better and better," said Zervos.

At 9:30 p.m., my wife called and sounded worried. She thought I'd been in a car accident.

I said good night and headed home. The next day, Jacqueline told me they'd looked at Pablo's entire output of prints for the year, almost 350 of them in all. When Zervos was about to leave (around midnight!), he said he'd never felt better.

October 3

The summer is almost behind us. Those who spent the warm season on the Côte d'Azur have begun to pack up their things. Marie Cuttoli and Henri Laugier came

by to say goodbye. There was another woman with them, though I didn't quite catch her name when she was introduced.

Marie was once very prominent in Parisian artistic and political circles. She's the widow of a former Radical Party senator. Although her husband wasn't exactly a household name, he often played a pivotal political role. Based on what I heard, more than one governmental ministry was put together at meetings in their home.

Marie is 90, and Henri must be more than 80. He loves to use vulgar expressions, in a display of reverse snobbery. They have a magnificent collection of paintings and objets d'art that they've bequeathed to the Louvre.

The woman with them is quite interested in painting and printmaking. I understand that she too is a painter, and has tried her hand at etching. As they were getting ready to go, I finally caught her name: Madame Couve de Murville, wife of the French prime minister.

October 11

I must have met Édouard Pignon and Hélène Parmelin, his wife, for the first time at Picasso's, shortly after the Second World War. I also remember an exhibition

of Pignon's paintings in the 1950s, in a gallery in the Faubourg Saint-Honoré district of Paris. Pignon completed the works in a Provençal village in the late summer. They depicted scenes of the harvesting of grapes and gnarled, tormented-looking olive trees, in a variety of shapes and colors.

On another occasion, I saw them at Picasso's home in Vallauris, in Provence, where he was living at the time with Françoise Gilot. Picasso's studio was located in the Fournas district, in an old building that was once a distillery. We all took lunch in the main courtyard, sitting on the ground and soaking up the warm spring sun. The simple, unpretentious atmosphere was characteristic of all of Picasso's get-togethers.

Picasso showed us some of his latest paintings. I remember one of them quite well, since I've seen it reproduced on many occasions since. It depicted the countryside around Vallauris: a few houses in the foreground, set against the blue expanse of the Mediterranean, with a small boat, a triangular white sail, and a few deckhands completing the scene.

Within the limited confines of the canvas, Picasso had managed to express all of the poetry inherent in that place and moment in time.

That afternoon, using my visit as an excuse, we explored the village and stopped in for coffee at a small tavern. A player piano was languishing in the corner, so Pignon cranked the handle and we all danced. The tavern was once the village bordello.

We then drove to Antibes and Saint-Paul-de-Vence. In Saint-Paul we stopped in for a drink at La Colombe d'Or, which is noted for the magnificent paintings hanging on its walls. We also popped in to see Verdet,[8] the poet, who offered us a few glasses of a local rosé. Then we visited Prévert.[9]

All of those memories came flooding back to me today when I saw Pignon and his wife, after a seventeen-year gap. They don't seem to have changed much. They both look blonder, sturdier, and more daunting. In the interim, they have begun to resemble each other, as couples often do—a case study in mimesis, though I wonder if any expert has ever taken the trouble to study the phenomenon.

I think Picasso was happy to see them. Not only are they colleagues of his, they're old friends. Édouard paints and Hélène is a writer, with numerous books and articles on Picasso to her credit.

They had lunch at Notre-Dame-de-Vie. After the meal, Picasso went up for his siesta, while Pignon stretched

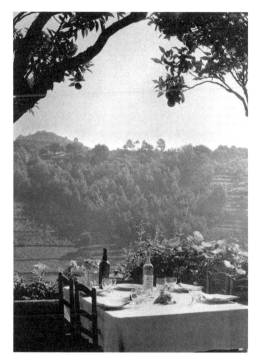

The terrace of La Colombe d'Or,
where Pablo Picasso liked to meet
his friends, the family of Paul Roux.

out on a bench to snooze in the garden. Jacqueline and
Hélène went down to the beach for a swim.

At five o'clock, naptime was over, and the women
had returned from the beach. We gathered in the living
room to look at some prints.

Picasso loves any excuse to revisit his work. On such
occasions, a thousand and one new ideas may come
bubbling up. But he is also plagued by self-doubt, just like

a young artist. Aside from hearing the standard words of praise, he likes to watch his friends' faces to gauge their genuine emotions.

Pignon and Hélène have different ways of reacting. He is the impassive technician, dispassionately assessing the evidence, whereas she cannot stop talking. Her commentary includes many adjectives and goes as far as to shout out the most unusual words that are the most powerful manifestations of her boundless enthusiasm.

After an hour they begin to show signs of fatigue, even though they've seen only a small portion of the prints. Picasso teases them, saying that if they're bored, he'll end the session. They protest that the etchings are very complicated: they have to examine them carefully to take in all of the detail. Picasso's ironic smile shows he is well aware that Hélène is not there to research artistic emotions. She is mostly looking for a telling detail that will enable her to finish off an article or to flesh out a new chapter in her book.

October 15

I haven't seen Picasso in a few days. Actually, I did catch a glimpse of him yesterday as he put a freshly painted frame against a wall to dry.

He's set aside printmaking and has taken up painting again. This is a new chapter for him. From March until quite recently, he didn't even pick up a brush. He seems nervous and unavailable. In moments like these, I turn into the "invisible man."

A number of people stopped by in the late afternoon: the Crommelynck brothers, who dropped off a few prints; William Hartmann, the Chicago-based architect who oversaw the installation of one of Picasso's sculptures in that city;[10] and Picasso's friend Arias, who owns a salon in Vallauris and sometimes stops by to cut the Maestro's hair.

Picasso showed us a strange-looking photograph he'd just received. It was a radiographic image of his portrait of Sabartés, one of the most important works from his Blue Period, which hangs in Barcelona's Picasso Museum. As was his custom at that time, Picasso had worked on top of an older painting depicting a woman wearing a hat, style circa 1900.

Picasso told us the woman was a model he'd worked with at the infamous Saint-Lazare women's prison, which no longer exists. At that time, the various categories of "offenders" included many prostitutes. Picasso was a friend of one of the prison doctors, who had authorized him to use the inmates as models. The earlier

painting, buried beneath the portrait of Sabartés, showed one of these women.

"If they did radiographs of all my paintings from the same period, there'd be lots of surprises. Pallarès often brought me eighteenth-century paintings, which he'd found in some convent or church somewhere."

Jacqueline said Picasso seemed quite restless. They slept badly last night because he kept talking in his sleep. Picasso explained: "I was dreaming I was back in some 'people's democracy.' I've been having this same dream for years now. I'm in some people's democracy; I don't quite know which one. I'm at some conference of painters and sculptors. We're discussing beauty, and, as sometimes happens among colleagues, we're not always in agreement." [11]

He also told us that he sometimes dreams he's arrived in England with no money. He checks his pockets and finds one gold coin—but it's so tiny he cannot possibly afford a hotel room. So he decides to go off in search of his friend Roland Penrose and then begins to feel better. [12]

October 16

A woman arrived this afternoon with two drawings. She wanted Picasso to look at them and to confirm whether he'd drawn them.

Picasso is busy painting and doesn't wish to see anyone. I walked down to the entrance gate to collect the drawings. One was dated 1923, the other 1955. Both were on the same-size paper. The color and design were so similar that at first it seemed odd that Picasso would have used identical materials, thirty-two years apart.

Both drawings were dated and signed. Jacqueline brought them to Picasso in his studio. He returned them after crossing out the signatures—they were both forgeries.

I gave the drawings back to the woman and relayed the bad news. She told me that one drawing was hers and the other belonged to a friend of hers. She'd paid 1,000 francs for her drawing, which she'd acquired from a woman who'd claimed to be in dire financial straits. She told me that, according to rumor, Picasso had given the drawings to a prominent person who lived in the region to settle a fine incurred by one of his sons.

I pointed out that fines can't be paid off with drawings and that if there had actually been a fine, Picasso could have afforded to settle the matter in the usual way.

The woman left with her drawings. If the story of the fine had been true, she would have been much happier.

October 21

Picasso can go for months without leaving the house or getting any exercise other than walking from one room to another: his bedroom to the studio, the studio to the kitchen (also the dining room), and then back to the studio or bedroom. The circle is thus complete.

He went down to Cannes this morning for a dentist's appointment. In the afternoon he went to the airport in Nice to see off some friends who were bound for Paris. Quite the odyssey!

I remember one winter in Paris fifteen years ago that Picasso spent confined to his house on the Rue des Grands-Augustins.

At that time he'd see his friends, or whomever else had reason to stop by, in the morning. Everyone would gather in an enormous room that simply defies definition or description. As in all of Picasso's homes, the space was filled with all sorts of different objects. As the guests waited for the Maestro to appear, Jaime Sabartés did his best to entertain them. Since every available chair was covered with various books and objects, everyone had to

wait standing up. Everyone, that is, except Sabartés, who sat down in a beat-up old armchair, as if presiding over a meeting. An hour or two later, Picasso finally appeared.

The Maestro's habits have changed a good deal since then. He now wakes up between 9:00 and 11:00 a.m. He has breakfast in bed and reads his mail. This keeps him occupied until lunchtime, after which he takes his siesta. He sleeps like a baby, with the windows wide open and the bedroom bathed in sunlight. Sometimes Jacqueline has me look at him while he's sleeping. I tiptoe into the bedroom, even though Picasso sleeps very soundly and is highly unlikely to awake. That must account for his astonishing powers of recovery.

He gets up again at four o'clock and begins work. His working day can be quite long, with only one short dinner break, and continuing until the early morning hours.

October 23

Georges Ramié and his wife stopped by Notre-
Dame-de-Vie this afternoon. During their recent stay
at the Amélie-les-Bains thermal spa, they visited the
museum in Céret, near the Spanish border. We should
never forget Céret's important role in Picasso's œuvre.[13]

The Ramiés dropped by to reminisce. They are
potters who live in Vallauris and let Picasso use their
oven during his first pottery experiments in the summer
of 1947, an experience Ramié described in a series of
articles. To appreciate Picasso's interest in this new form
of expression, we must bear in mind that, to some
extent, pottery is an art form in which painting and
sculpture seem to converge. Picasso initially devoted
himself wholeheartedly to pottery, although his output
eventually became more sporadic. Vallauris thus owes a
good deal of its fame to Picasso.

Picasso gave free rein to his creative fantasies during
this new phase of his plastic œuvre. To his mind, the
results obtained by placing freshly modeled clay into the
fire, with all the variability inherent in the process, were
never less than extraordinary. The fruits of this period
are on display in museums in Antibes and Céret.

Pablo Picasso at work in his garden.

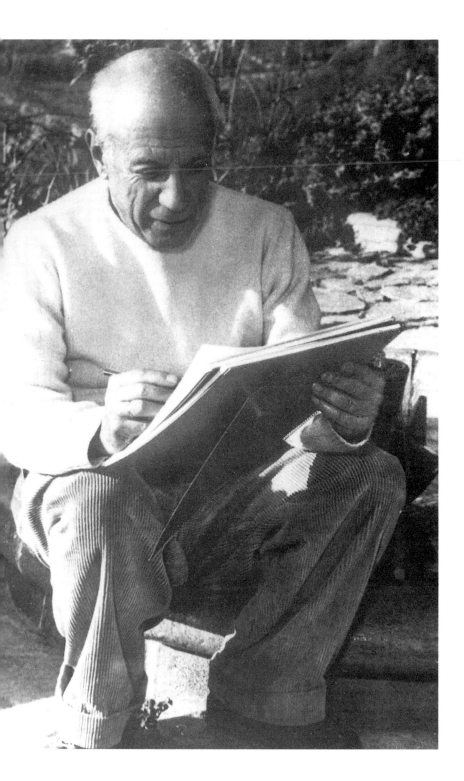

October 25

Picasso turned 87 today. For the past couple of days, the house has been in "quarantine." Absolutely no visitors are allowed, and if people phone asking for Pablo or Jacqueline, we're supposed to tell them they're out of town. In past years on this same date, they were off "traveling" in Switzerland or the Alps. This time we decide to say they're staying at Amélie-les-Bains.

When I arrived this morning, Jacqueline told me they'd both been sick during the night. She thought the fish they'd eaten for dinner might be the culprit. As luck would have it, Dr. Stéhelin, the family physician, is on vacation in Switzerland for a few days. Jacqueline already spoke to him on the phone. If Picasso's fever gets any worse, the doctor will fly back immediately.

The phone won't stop ringing. Picasso's friends all want to wish him a happy birthday. Reporters are seeking information to complete their articles. Flowers and gifts are pouring in from all over. The chauffeur and the gardener spent the entire day going down to collect them at the entrance gate.

I asked the post office to deliver the telegrams in a

bunch—dozens and dozens of them. They come from the four corners of the globe, destined for one of the most important figures of the 20th century.

That afternoon, Jacqueline told me Picasso had spent the entire day sleeping. As is his custom, he's recuperating after a sleepless night.

A television crew showed up at the door and requested access to the grounds. They said that the mayor of Vallauris is supposed to stop by to wish Picasso a happy birthday. I told them over the intercom that no one is home.

I saw Jacqueline again at five o'clock. Picasso's temperature had fallen, and she was feeling better too. There was a smile on her face.

October 26

When I arrived this morning, I asked Jacqueline, "How's Pablo?" With a smile, she asked, "Can't you tell?" Indeed, just by looking at her, I knew he was feeling better.

But I wanted her to confirm it. He had slept well but still has a slight fever.

Presents were piled up in the antechamber, and bouquets of flowers were taking up space in the living

room on the ground floor.

As he did yesterday, Picasso spent much of the day sleeping. He eventually woke up, sitting up in bed and leafing through some books and magazines for a few moments. He then fell back to sleep with surprising ease. He still had a touch of fever around 5:00 p.m. but was in good spirits. Jacqueline urged him to get dressed and to walk around the house a little. That would give him a chance to see all of his birthday presents.

I found Picasso sitting in the living room. Since I didn't see him yesterday, I greeted him with a kiss. "What a strange birthday!" he said. "I spent all of the day in my room, in the darkness."

Jacqueline and Cathy [14] showed him the gifts and read aloud the various birthday greetings. "When I was a child," Picasso said, "and I got presents for my birthday or Christmas, I'd get so emotional, I'd start crying as soon as I was alone."

He was visibly moved. For Picasso, the telegrams, the letters, and the gifts he receives, whether lavish or modest, are all priceless declarations of friendship.

One of the packages on the table contained a belt. Someone pointed out that the item was available virtually everywhere, costing only a few francs. "That

doesn't matter," Picasso said. "It's quite beautiful."

Contrary to what some may think, Picasso has no idea how much things really cost. However, he knows perfectly well which person sent him which gift. And perhaps he prefers this modest offering to the more expensive things his friends and admirers sent him for his birthday.

October 29

Since Picasso took up painting again, I've been seeing less of him. Picasso the painter and Picasso the printmaker are two different people. The difference stems from the fact that he identifies with his work so much. As a result, he has to adapt to a different technique, and this alters his behavior. The Picasso hunched over a copper plate is much more accessible than the Picasso communicating a slice of his universe onto the canvas, paintbrush in hand and tubes of colored paint strewn at his feet. I don't know the reason for this change. Perhaps it's easier for an engraver to resume tracing a line he briefly interrupted than it is for a painter to keep on adding shapes and colors to the canvas. I have no idea. Perhaps I'll get a chance to ask him one of these days. All I know is that I've had to disturb him on sever-

al occasions when he was etching to tell him that some-
one was at the door or on the phone. But I would never
dare disturb him if he was painting in his studio.

Inés Sassier stopped by this afternoon. She took a
seat in Jacqueline's "office," and, as is their custom, she
and Jacqueline chatted for a little while. Inés is much
more than a visitor; she's a friend of the family.

More than thirty years ago, Picasso met Inés and her
sister Marinette during a long stay at Mougins. At that
time, they made their living as all the other young
women of the village did, picking flowers in the country-
side for the local perfume factories. In the summer,
when the tourists and holiday-makers arrived *en masse*,
they'd find work in a hotel. That was how Picasso came
to meet the Sassier sisters.

Picasso brought both of them up to Paris at the end
of the summer. At that time, he was living on the Rue de
La Boétie. Marinette didn't take too well to life in the
big city and returned to Mougins shortly thereafter,
while Inés remained in Picasso's employ.

Beginning in the apartment on the Rue de La
Boétie, and later on in the studio on the Rue des
Grands-Augustins, Inés served as Picasso's faithful
keeper. As a discreet and tactful observer of the numer-

ous stormy episodes that marked his love life, she always kept a watchful eye on the Maestro. When he and Jacqueline settled permanently on the Côte d'Azur, Inés stayed behind in Paris to look after the Grands-Augustins studio. Many of Picasso's paintings and sculptures remained in storage there until a series of unpleasant maneuvers led to his eviction.

Inés currently lives in the village of Mougins with her husband and her son, who is now 22. They bought an old house on a hill overlooking the Mediterranean and the Lérins Islands. The father and son run a small bookstore just outside of Cannes. After many years of hard work, the family now enjoys a peaceful and comfortable life in one of the most beautiful parts of France.

As I mentioned, Inés is a regular visitor to the house. Jacqueline feels great affection for her and is very grateful to her because of everything she's done for Pablo. Inés is a true friend, one of those rare people who receive the warmest of welcomes whenever the Picassos hear her name.

It's almost seven o'clock, and I'm in my tiny office. The phone rings. Someone asks for Inés. Judging by the caller's tone of voice, it must be something urgent. After a few moments, Jacqueline and Inés come downstairs.

Jacqueline asks the chauffeur to get her Alfa Romeo ready. She is going to drive Inés down to Mougins, since Jacqueline drives faster than anyone I know.

The women return half an hour later, with Inés in tears. Jacqueline informs us that Inés's husband, Gustave, was struck by a car in Mougins. He suffered a fractured leg and head injuries. An ambulance rushed him to the hospital, where the doctor is reserving his diagnosis.

October 31

When I arrived the next morning, I saw Inés, who spent the night at Notre-Dame-de-Vie. Her husband is being operated on, and the results won't be known for a few hours. Jacqueline and I try to keep her distracted by finding a thousand and one topics of conversation. From time to time, Inés loses her composure, despite her valiant efforts.

Shortly after noon, I drove Inés down to the hospital. We'd already received a phone call informing us that her husband had been operated on for a double fracture in his right leg. As for the other injuries, the doctors will need a few days before they can come to a decision.

Gustave is still feeling the effects of the anesthetic. His

son and a number of other family members are gathered around his bedside. I left Inés with her husband and returned a few hours later to collect her.

Jacqueline chose to tell Picasso a somewhat different version of events. She downplayed the seriousness of the incident, telling him that Gustave had simply injured himself working in his garden. She is always watching out for Picasso. If she does have to upset him with something, she does everything she can to soften the blow.

November 12

This morning, there was a France Culture radio program on Barcelona's plastic-arts scene from the early twentieth century through today. The reporter was interviewing someone whose voice I seemed to recognize— it turned out to be Josep Palau i Fabre.[15]

Palau answered the journalist's questions in detail, providing names of artists and publications and dates. He is a serious researcher, at once patient and persistent. I was able to observe these traits up close during his recent visit.

Palau has written several books on Picasso. He plans to record every aspect of Picasso's life and œuvre on

index cards. Every time he comes over, he has a new questionnaire with which he interrogates Picasso, or so it seems. I must say that a couple of things surprised me during Palau's last visit two months ago: Picasso's extraordinary patience and his prodigious memory. Palau asked him questions such as "In what year did you spend the summer in such and such village?" and "Who owned the house where you stayed on vacation?" The other questions were along the same lines. The most surprising thing was that Picasso, who normally can't stand journalists or people who pry into the affairs of others, answered all of the questions with a smile, visibly eager to indulge Palau's curiosity.

A few days ago I popped in to say hello to Pablo, who was busy reading a book. It was Palau's *Doble ensayo sobre Picasso*.[16] "It's quite good," he said. "But I only have one copy. I'll give you one when I get some more." Picasso loves work that is thorough and well done.

November 14

Miguel and Juan Gaspar are brothers who own a gallery in Barcelona. They were close friends of Jaime Sabartés and have known Pablo and Jacqueline for many years. They were recently in Paris on business and,

before heading back to Barcelona, they stopped in to visit Picasso. I told them on the phone that Pablo would see them at five o'clock. They were at the entrance gate right on time.

The brothers are in their fifties. They're jovial and pleasant and never stop talking. Since I've lived in France for so many years, I always feel a mixture of kindness and surprise whenever I encounter any of my compatriots.

Above all, they are here to pay their respects to the Maestro, but, like all of Picasso's visitors, they've come with a "wish list." Out of curiosity, I made a note of the points raised by "the Gaspars," as Pablo and Jacqueline call them:

1. Two photos of paintings signed by Picasso to be authenticated by him (both turn out to be fakes).

2. Barcelona's art critics have decided to cast a gold medal in Picasso's honor, and they want to send a delegation to present him with the medal.

3. A delegation from Friends of the Museums of Barcelona would like to thank the Maestro for his gifts to Barcelona's Picasso Museum.

4. The committee organizing a tribute to Pompeu Fabra has requested a drawing.[17]

5. There are two manuscripts for a possible new

edition of Sabartés's works.

Picasso picks up a large piece of paper and a ball-point pen. In the twinkling of an eye, he's finished a drawing. It's what he calls a Rembrandt, since the style suggests the Dutch painter. Nowadays, whenever Picasso needs to do a quick sketch, he draws a Rembrandt. He produces dozens if not hundreds of them—how many, I can't really say. All of them feature a superb rendering of a seventeenth-century knight.

As for the art critics and museum groups, Picasso says he is very grateful they would wish to honor him, but he prefers to work in peace.

That evening I drove the Gaspars back down to Cannes. They suggested we eat dinner together, but I invented some excuse, and we settled for a drink in a bar. As I sat between them, I kept turning my head back and forth to keep up with whichever brother was talking. When they both spoke at the same time, I didn't know which way to turn.

November 18

Michel and Zette Leiris arrived in Cannes two days ago. They stopped by to show Picasso a catalogue for an exhibition of his etchings. The exhibition is set to open at the Galerie Leiris on December 18.

Zette Leiris, who runs the gallery, is the sister-in-law of Daniel-Henry Kahnweiler,[18] the famous art dealer and Picasso's friend since the Cubist era. The Galerie Kahnweiler became the Galerie Leiris after the Second World War.[19] Kahnweiler is approximately the same age as Picasso and still drops by the gallery every day to do some work. However, he's mainly interested in books and conferences because he's a writer and a lecturer, and he prefers to leave the management and the administrative duties to Zette Leiris and other colleagues. Michel Leiris is a well-known writer who was associated with the Surrealists. From what I can tell, he seems to be a bit of an anarchist, judging by his political comments. He's certainly angst-ridden, a fellow who spends so much time wondering about the meaning of life, he's no longer sure what he's doing here on earth.

Zette and Michel are old friends of the family. They're staying at the Hotel Carlton in Cannes, but are taking their meals at Notre-Dame-de-Vie.

Zette is very worried. The etchings she intends to show are supposed to appear in the exhibition catalogue. Owing to their overtly risqué nature, approximately twenty prints—known as the Raphael and Fornarina series—can't really be shown in a public exhibition open to both adults and children. Nor can they be shown if several thousand copies of the catalogue end up being distributed.

The Raphael and La Fornarina series is made up of the last of Picasso's etchings from this past summer. The subject matter is consistently the same: love—or, more precisely, the act of love. The prints are truly beautiful, with very pure lines. With them, Picasso has proved that it is possible to treat erotic themes without lapsing into obscenity. They bear tender witness to the artist's respect for the most authentically human aspects of the relationships between men and women.

Zette has been pondering this dilemma for several days now, but she doesn't know how to broach the subject with Picasso. It appears that a number of self-appointed moral guardians—certain associations—won't hesitate to take legal action if the etchings are shown or reproduced in the exhibition catalog.

All of her other questions have been answered. The car that is supposed to take the Leirises to the airport in

Nice is waiting. Zette tells me she didn't dare raise the matter with Picasso, so she's planning to write him a letter about it tomorrow.

November 23

Jacqueline drove down to the airport in Nice early this morning. When I got here, I realized she'd taken her Alfa Romeo. She was off to collect Maître Roland Dumas, a lawyer from Paris who's going to represent Picasso in a lawsuit brought by his son Claude.[20] (Claude's mother is Françoise Gilot.) The case will be heard in Grasse.

Claude has already received legal authorization to use the Picasso name. Now that he's reached the age of majority, he's filing suit to force Picasso to recognize him as his legitimate son. Dumas is here to plan his courtroom strategy.

Ever since he learned that Dumas would be coming, Picasso has been nervous and in a bad mood. He understands Claude's desire for legal recognition but doesn't agree with his tactics, i.e., taking legal action. In addition, Picasso has claimed, somewhat bitterly, that his son is motivated not so much by a desire to normalize his

situation than by a desire to share in a future inheritance that will be substantial, even if split many ways.

Picasso always finds such meetings unpleasant. In the first place, he finds legal jargon almost unintelligible. In addition, the lawyer is making a special trip from Paris and will have to be entertained at lunch and, perhaps, dinner as well. Indeed, Dumas will end up spending many hours with Picasso discussing various aspects of the case. But no matter how important the issues may be, they don't fire Picasso's passion. To make matters worse, Dumas is arriving early in the morning, and Picasso works almost until dawn and doesn't get up until lunchtime. If Picasso is ever around in the early morning hours, it's not because he got up early; it just means he hasn't gone to bed yet. That should give some indication as to his current state of mind.

Maître Dumas is a nice-looking and well-mannered young man. Shortly after his arrival at ten o'clock, Picasso was still in bed so Jacqueline showed Dumas into the living room, and they conferred until noon.

Just after lunch, I managed to get in a few words with the lawyer. In his view, Picasso's position is contradictory. On the one hand, Picasso understands and

almost approves of what Claude is doing; on the other hand, he seems firmly opposed to his son's objectives.

Based on my previous discussions with Picasso on the subject, I knew he was enormously worried by the case because he didn't know which position to take. The lawyer told me that at one point, Picasso had interrupted him to ask, "What would you do if you were me?" Dumas told him that he would first try to win the case and would then draw up a will stating his desire to leave a portion of his fortune to his children, legitimate or otherwise. I told Dumas that his strategy was like spanking a child after he's done something wrong and giving him candy afterward to make him feel better.

In fact, Picasso's question was not only a sign of confusion, it was a tactical maneuver: stalling for time, gauging the other person's reaction, and concealing his own feelings.

Later on, I jokingly asked Picasso if the meeting had been hard on him because he'd had to get up so early.

"That's right," he said. "But it wasn't as bad as I thought it would be. I've been in such a foul mood for the past few days, dreading this meeting. I'd painted such a negative picture in my mind, but in fact it wasn't so terrible."

Picasso is happy because he thinks the matter is settled, at least for the moment. Now he can get back to the only thing that really interests him: work

December 4

The first copies of *Les quatre petites filles*,[21] a play written by Picasso and published by Gallimard, arrived at Notre-Dame-de-Vie today. It's a theatrical work in six acts but very difficult to define in terms of genre. Picasso began work on it in the village of Golfe-Juan on November 24, 1947, and finished it in Vallauris on August 13, 1948.

Like his other literary works, this play is really a poem. The story itself—little girls at play in a garden on a summer afternoon—is so slight that the author simply uses it as a backdrop. But in the foreground, he offers up a bravura display of explosions and pyrotechnics, creating a network of dazzlingly inventive sentences. Although there is scant connection between the individual phrases, set side by side, they form a beautiful and colorful whole.

Sometimes I wonder why Picasso writes. He has demonstrated time and time again that he is able to express any idea with his paintbrushes, whenever and however he likes. Why does he need to resort to another idiom? In fact,

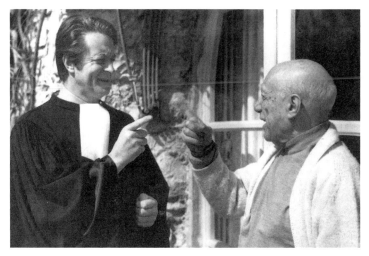

Roland Dumas and Pablo Picasso in Notre-Dame-de-Vie.

Picasso doesn't believe he's expressed everything he has to say—not by a long shot. If you could see him in action, or see how impatient he is, or see what his hands are capable of producing, or see how many discoveries he can concentrate in a single canvas or print, you would come to only one conclusion: his hands alone are insufficient for the task, and he never has enough hours in the day.

Given these factors, literature is another way for Picasso to create hundreds or thousands of "themes" that accrue on the printed page, phrase after phrase. But we must keep one thing in mind: his sentences may be a disconnected series of descriptions, but he evokes shapes and colors with great clarity. Picasso is a painter even when he's writing.

The most surprising qualities about Picasso are his extreme youthfulness and curiosity. Today he is happy his book has been published, as if he were a novice author.

I came back to get his signature on some document. He was holding a copy of *Les quatre petites filles*, in which he wrote a dedication for me. He finished the inscription and then drew a few lines or simple stripes on each page, in alternating colors. The book now bears his personal imprint, from the first page to the last: "To my friend Miguel." I am so moved, all I can say is "thank you."

December 6

When Picasso saw me this morning, he asked if I'd had a chance to look at his new book. "I didn't just look at it," I said, "I devoured it in one sitting. That's why I know the four little girls entertained themselves by burning butterfly wings. They also liked looking at a pan full of fried stars buried at the bottom of a well."

Picasso smiled and said he was a writer who doesn't know how to write.

I mentioned the first literary effort of his I'd read, a poem entitled "La corrida de luto." [22] Picasso had given me the original manuscript, which I then dictated to Jaime Sabartés. Sabartés was a better typist than I was,

so he typed out a few copies. I remember that a number of passages were very funny. Picasso's scenarios were quite farfetched and bewildering, and, at times, they left me howling with laughter as I tried to read them aloud. Picasso was painting in the adjoining studio, and he'd come in from time to time to ask me why I was laughing so hard. I'd show him the source of my amusement, and he'd say, half-jokingly, "At least my poem got you laughing. And that's something!"

That was almost twenty years ago. Picasso has no idea what happened to the poem. I asked Jacqueline, who has heard of it but has never seen it. When I suggested it might have gotten lost, Jacqueline said, "Oh, no! It's not lost, just misplaced." A question of semantics!

December 7

I told Picasso that Madame Ramié was on the phone. He spoke to her and then mentioned that he was hot and sweaty. Indeed, his shirt was soaked right through. "I'm in the middle of a very difficult project. I have to work so hard that I'm drenched with sweat." "What kind of work requires such a huge effort?" I asked. "Come and see," he said.

I followed him into his studio, and he showed me the object of his labors. A square piece of wood, approximately ten inches wide, was lying on the table. Attached to the wood was a piece of linoleum that Picasso was engraving.

Picasso explained: "When using an engraver's chisel, you shouldn't use more than the force of your own hand. The professionals say the hollowing-out should be done very gradually, removing only a small amount of material each time. But I've been pushing down with my arm, my shoulder, and my whole body. So I've been carving out the grooves in a single motion."

We chatted for a few minutes. Picasso asked if I had any news about my son, who's studying in Paris.

"He's doing fine," I said. "He'll be here in just a few days. He's going to spend the Christmas vacation with us."

"Ah, vacation! That's just what I need, a nice vacation!"

"And what would you do if you took a vacation?" I asked.

"What do you think I'd do?" he asked. His tone grew quite serious. "I'd work."

December 10

Jacqueline was furious when I arrived at Notre-Dame-de-Vie yesterday. A Paris newspaper published comments made by an art dealer in an Italian restaurant. He was quoted as saying that it was impossible to see Picasso, that his wife kept him locked up, that her name was Jacqueline, and so on.

I tried to calm her down.

People want access to Picasso. They want to see him and ask him a thousand favors. If they're unsuccessful, they look for a scapegoat. I remember that those who couldn't gain admittance to the studio on the Rue des Grands-Augustins would blame Jaime Sabartés. For some time now, they've been taking it out on Jacqueline whenever their attempts to see or speak with the Maestro fail.

But how are we supposed to tell people the truth? When Picasso is painting or etching, his work is the only thing that matters. He refuses to see the journalist from Paris or the novice painter from Barcelona. Nor will he welcome the publisher from Germany, the art dealer from America, or the group of students from Italy. The museum curator from Holland, the antiques dealer who wants to sell him some rare item, and the poet who'd

like to stop by with a collection of poems he's dedicated to Picasso will all be refused entry. So too will the representatives of the disabled children's organization, the disabled war veterans, the collectors, and the fans— almost no one manages to get in.

If we didn't screen the visitors in this way, if we actually responded to the letters, if we didn't tell people on the phone that "Monsieur and Madame are out," Picasso would be surrounded, inundated, and dragged under by hordes of well-wishers and petition bearers. Even an oak tree couldn't survive an avalanche of such proportions. And Picasso's work, and his health, would suffer as a result.

Madame Gris, the widow of the famous Cubist painter[23] who was Picasso's childhood friend, came by for lunch at Notre-Dame-de-Vie yesterday at noon. She's heading off to Paris and came to say goodbye.

Jean Leymarie, along with Renato Guttuso and his wife, dropped in for a visit in the afternoon. Leymarie has been appointed curator of the Museum of Modern Art in Paris. He told me he's hoping that Picasso will donate several paintings. I remember that Picasso donated artworks currently hanging in the museum.

Renato Guttuso is a fairly well-known Italian painter.[24]

He looks and sounds like an opera singer. His wife is a countess; Renato is a communist. A curious alliance of a proletarian and an aristocrat!

We are together in the living room. Some of the guests are drinking whiskey. We are sitting at a table that Picasso often uses when drawing or etching.

Picasso is reminiscing about Rome. He mentions being invited once to dine at the home of the "Marquise de C." Her huge dining room had several magnificent candelabras; an exotic bird sat in one corner of the room, bathed in red light. The guests included ambassadors and luminaries from the political and art worlds. The doors swung open to reveal the mistress of the house, draped in some kind of see-through fishnet, trimmed in gold.

Madame Guttuso told us that the Marquise de C. had died a pauper, living in a disgusting attic. But until the end, she would don what had once been a magnificent sable coat—but it was then so threadbare, all that remained was the lining and a few strands of hair.

The gathering was turning into an open forum of sorts. Picasso began to show signs of impatience, as if he were wasting his time. He has a thousand things to do and cannot understand how we can remain so inactive, as if we had all the time in the world ahead of us.

December 11

A number of visitors are expected today: Rafael Alberti and his wife, María Teresa León, along with their daughter Aitana de Otero and her husband.[25] The Ramiés are supposed to come by to pick up the latest linoleum engravings. Also expected is Georges Tabaraud, the editor-in-chief of a newspaper in Nice and an old family friend.

At the last minute, someone calls up to say that a group from Málaga has arrived bearing gifts for the Maestro.

This proves too much for Picasso. I go down to the entrance gate myself to tell the visitors from Málaga that Picasso is out and that they can leave the gifts with me. They tell me that they are there on behalf of a group of influential Malagueños who've launched a campaign to name a square in Málaga after Picasso.

They have brought a copy of a petition presented to the mayor of Málaga, in addition to numerous pages of signatures. There are also gifts, the most noteworthy being a painting by Martínez de la Vega, a painter who lived in Málaga in the late nineteenth century.[26] De la Vega was a friend and companion of Picasso's father, who was a painter and professor at various schools of fine art in Spain.

The members of the group are obviously and understandably upset, and I do my very best to minimize their disappointment. They ask me to pass along greetings from hundreds and thousands of Malagueños, who send Picasso their warmest wishes. There are hugs and kisses all around, and I promise to deliver their message without fail. I emphasize that Picasso will be very sorry to have missed them, etc.

When I deliver the gifts and greetings, Picasso is filled with remorse. If he could do it over again, he would meet with the group and give them a warm welcome.

Jacqueline and Pablo Picasso in Mougins in 1971.

That was the first time I met Rafael Alberti and María Teresa León. I'm familiar with his work, at least in part, and I've heard of them for many years.

I soon realized that Alberti monopolizes the conversation wherever he goes. I tell him I read his preface to Picasso's *The Burial of the Count de Orgaz*. He's obviously quite pleased with himself. He waves his arms about as he talks, sipping his whiskey.

He relates a number of his earliest memories. He tells us he studied English as a child: exactly eleven lessons, no more, no less. He remembers them all perfectly. To convince us, he insists on reciting them. He is from Andalusia and lived for many years in Argentina, France, and Italy. His accent is so strange, no one can understand a thing he says.

He tells Picasso he is prepared to work with him on any project the Maestro wishes. He suggests an erotic poem based on the Raphael and La Fornarina etchings—a poem destined to outrank even Ovid. As the whiskey continues to flow from bottle to glass to stomach, Alberti admits to feeling indifferent about everything except Picasso's œuvre.

Picasso writes a dedication for him in a copy of *Les quatre petites filles*. María says to me it is a marvelous work that should be translated into Spanish. The translation

should be impeccable, a work of great sophistication. She offers her services.

She also mentions to me a show she's working on with Italy's RTV network. She is quite determined to secure Picasso's participation in the project, certain segments of which will be filmed at Notre-Dame-de-Vie. I am apparently supposed to assist her in her bid to win over Picasso. I let her go on talking without contradicting her, though I promise nothing.

Alberti is still reminiscing, holding forth about a trip to England to attend a Peace Congress. Only a small number of the prospective attendees, Picasso among them, were allowed any further than the London airport. Many locals had come bearing bouquets of flowers to greet the arrivals. When they caught sight of the Maestro, they starting chanting, "Picasso! Peace!" Alberti told us he thought they were saying, "Picasso! Piss!"

Every time Picasso shows him another drawing or print, Alberti says he will write about Picasso and his œuvre. "There's so much that remains to be said about you," Alberti said. "The French are so chauvinistic. When they talk about you, they never tell the whole story."

The Albertis have rented a house in Antibes for a month. As they were leaving, they kept on saying they'd be back. All Picasso has to do is let them know when he'd like to see them again.

I told Pablo and Jacqueline that I found the Albertis quite tumultuous. "But they were quite calm today!" Jacqueline exclaimed.

December 18

Twin Picasso exhibitions opened today in Paris and Chicago, featuring 347 etchings completed between March and October of this year.

I believe I've already mentioned how difficult it is to display some of these works: the realistic subject matter could lead to legal or administrative battles, which Picasso might find quite painful. I also want to mention in passing that this prospect has troubled some of his closest associates. However, I'm sure he's never even considered the possibility of such problems. And even if he had, he'd surely think they were trivial.

The twenty or so prints in question—the Raphael and La Fornarina series—were hung discreetly at the Galerie Leiris in a tiny, closed-off space adjoining the

main hall where the other prints were being shown. Only a happy few were allowed to enter the smaller room.

A similar solution was devised for the catalogue. The Raphael and La Fornarina pages were placed in a sepa-rate envelope, which was distributed to only a select few. Picasso finds the whole situation quite amusing. He has never sought to stir up scandal, but if some people's Puritanism and hypocrisy trigger one, that's not his problem.

Telegrams and phone calls started flooding in during the early afternoon. Picasso seems completely serene, as if he were saying, "Who cares about all of that?" But if his work is making such a splash, he can hardly feel indifferent, and in fact, he isn't. Quite the opposite!

I haven't seen the exhibition, and I don't expect I'll get a chance to. Although I'm familiar with all of his engravings, I would enjoy seeing them hung side by side, in chronological order, so that I could study the evolution of his thought, along with the genesis, development, multiplication, and disappearance of his characters. On several occasions, I've seen prints in portfolio containers, although they were all mixed up and in no coherent order. I'd like to stop by the gallery, perhaps in the morning when the grandes dames who flock to exhibitions are

still sleeping. But I'll just have to rely on my imagination: Cannes to Paris is just too far.

I have a son who is 20 living in Paris. He dropped into the exhibition today, and I asked him what he thought. He said, "I thought the most surprising thing was the joy that radiates from his works. How can such an old man be so young?" I often wonder that myself, even though I get to see him every day, living and working.

December 20

Alberti was very insistent that he should receive the first catalogue of Picasso's etchings as soon as it's ready. Since Jacqueline thinks of everything and she was in the neighborhood, she dropped off a copy for him at his home in Antibes.

Today the Albertis are back at Notre-Dame-de-Vie. Keep in mind that there are actually four of them: Rafael, María Teresa, their daughter Aitana, and her husband, Otero. We—Picasso and Jacqueline, the four visitors, and myself—gather around a table in the living room.

Alberti recites a number of poems inspired by the Raphael and La Fornarina series. In some of the etch-

ings, Picasso includes several "walk-ons," in addition to the main characters. Considering the nature of the activity Raphael and his model are engaged in, we may well appreciate the unflattering role of the secondary characters. One of the walk-ons is Michelangelo, and, judging by his miter-like headdress, the other is a pope.

Everyone knows that Picasso always has a number of trump cards up his sleeve. I have always believed that one of his finest qualities is his indomitable zest for freedom. He does whatever he wishes, however he wishes. He believes it's the only way things should be. One can only be genuine with others if one is genuine with oneself first.

Alberti is still reciting his poems. The various characters in the etchings are speaking to Picasso, each in turn: Fornarina, Raphael, Michelangelo, and the Pope. They speak in the idiom and style of their period. The poet's free verse slips and slides—a series of smooth and well-turned phrases.

Alberti's poems were inspired by the reproductions in the exhibition catalogue. He wrote them in Antibes, in an old house next door to the Grimaldi Palace, overlooking the ramparts and the Mediterranean.

Alberti tells us he intends to publish a volume of poems he's written about Picasso. He'd also like the Maestro to do his portrait, and Picasso just might execute it. But the finished work will arrive when least expected, on a day when everyone else has forgotten about it. One day, Picasso will put pencil to paper and produce one—or, perhaps, twenty—portraits. Until that day, we must all remain patient.

December 21

In the late afternoon, I drove Pilar Solano to the airport in Nice. She had spent the day with Picasso and Jacqueline at Notre-Dame-de-Vie. She is heading back to Barcelona, where she is the curator of the Picasso Museum.

You were going to ask: "But who is Pilar Solano?" It would be best to start at the beginning.

Jaime Sabartés once traveled to Barcelona and was staying at a hotel in the center of town. On his second or third night, just before going to bed, he found a 1,000-peseta banknote, with a note attached to it, sitting on a chest of drawers in his room. While cleaning, the maid had found the banknote and left a message that said simply, "I found this on the ground." The message was signed "Pilar Solano."

Some time later in Paris, Sabartés, who was a widower and by this time in poor health, realized he needed someone to take care of him. She had to be hard-working, honest, and neat—all the qualities one might desire in a housemate. So he thought of Pilar.

Shortly thereafter, Sabartés was stricken with paralysis. Pilar took care of him as if he were her own father. For seven years Sabartés was disabled, always slumped in his armchair. But Pilar catered to his every need, caring for him, spoiling him. Sabartés was extremely lucky to have met her. Shortly before his death, he drew up a will making her his beneficiary.

Sabartés's apartment had originally been purchased by Picasso to provide his friend with a place to live. After Sabartés died, Picasso gave the apartment to Pilar.

Sabartés had an important collection of Picassos, which were subsequently donated to the city of Barcelona, with Pilar appointed as curator. The artworks were transported to an old palace on the Calle de la Moncada and went on to form an essential part of the collection at Barcelona's Picasso Museum.

Pilar went up to Paris to see the exhibition of etchings at the Galerie Leiris. Before returning to Barcelona, she stopped off in Cannes to pay her respects to Pablo and

Jacqueline. As I was driving her back to the airport in Nice, we stopped off in Antibes to visit the Picasso Museum. The curator, Monsieur de la Souchère, was not in. Pilar asked a staff member to pass along her greetings. She told him her name and emphasized her official job title as curator. Because I know and respect her, all I could do was smile.

December 23

When I arrived at Notre-Dame-de-Vie this morning, Jacqueline came out to meet me. She looked as if she'd had no sleep at all. Picasso is sick and has a fever. She'd already called Dr. Stéhelin on the phone.

We spent the whole day rushing around. Picasso is having a "liver attack." The chauffeur went to pick up various prescriptions. As luck would have it, today is Monday and all the pharmacies are closed. We had to find an emergency pharmacist somewhere and wait in line. It was all very time-consuming, and Jacqueline had a hard time staying calm. Around 11:00 a.m., Dr. Fourest stopped by. Tests will have to be run. Then a nurse came to administer some injections. She returned later in the afternoon.

In between visits with the doctor and the nurse, Picasso slept. He was tapping into his powers of recovery,

trying to get some rest. In contrast, Jacqueline couldn't sit still and barely ate a thing. She was up all night and all day taking care of Picasso.

Except for the doctors and various employees, no one must know that Picasso is ill. We have to make sure that the press and other media don't find out. Given their taste for sensationalism, many journalists would be all too ready to exaggerate the situation and to print the craziest things. Even sick with a fever, Picasso reads the papers. In this case, discretion is the better part of prudence.

December 31

The patient is well on his way to recovery. The combination of effective treatment, Jacqueline's constant care, and Picasso's exceptional vigor enabled him to triumph over his bout of illness.

Over the next few days, his fever came down and he resumed drawing. In the afternoons, he'd get up for a few moments to air out the room. He spent his time in bed reading, drawing, and sleeping.

Under normal circumstances, Picasso pays little heed to what time of day it is. Now that he's sick and confined to bed, day and night have lost their meaning

altogether. The aggrieved party ends up being Jacqueline, since Picasso wakes at the oddest times, in the middle of the night. He'll start reading and, if he remembers something he's been meaning to tell her, he'll speak up without blinking an eye. He'll comment on some event or offer his opinion on some book or some other such question. And when he feels tired again, an hour or two later, he'll drift back to sleep without any difficulty. The problem is that Jacqueline often ends up watching the sunrise without having slept a wink.

Since Picasso is ill, whenever I go upstairs to confer with Jacqueline, I ask, "How is he?"

Sometimes I don't ask, but the look on my face must give me away, because I usually receive a response. On two or three occasions, I've gone into Picasso's bedroom to pay my respects.

This afternoon, while his bed was being made up, Picasso spent a few moments in Jacqueline's office. I sat across from him while he drank a cup of tea. He still looked a little pale and seemed tired, all wrapped up in his dressing gown. I asked him how he was feeling and wondered if he'd found it frustrating to be cooped up in bed for so long.

"Why do you keep asking me how I'm feeling? You know better than I do. At least they're truthful with you. They tell me whatever they like. But I will say this: I feel fine, and I've always felt fine. I didn't suffer at all, except for the first night. And I slept a lot."

He asked me if I'd received a copy of the Paris exhibition catalogue. When I said I hadn't, he got up, retrieved a copy and wrote a dedication in it for me. "It's a Rembrandt," he said.

I thanked him. It was so touching to watch him recover after all the anxiety of the past few days, and I was quite moved to see his enduring kindness and sympathy.

"Thank you for accepting it," he said as he handed me the catalogue.

1- *A village on the French Riviera, located between Cannes and Grasse.*
2- *Jaime Sabartés, born in 1881 in Barcelona and died in 1968 in Paris, was Picasso's close friend and personal secretary.*
3- *This character appears in* La Celestina, *a tragicomedy by Fernando de Rojas, published in Burgos, Spain, in 1499. In Spanish literature, the name traditionally refers to a procuress.*
4- *Pepe Hillo (José Delgado Guerra) was born in Seville in 1754 and died in Madrid in 1801. He was one of the three most famous toreros of his period, along with Costillares and Pedro Romero. His treatise on bullfighting was published in 1796.*
5- *In Spanish,* El entierro del Conde de Orgaz.
6- *Jaime Sabartés,* Picasso, portraits et souvenirs, *Louis Carré et Maximilien Vox, Paris, 1946.*
7- *Horta de San Juan, Catalonia.*

8- *The French poet and artist André Verdet was born in 1913. He played an active role in the Resistance.*

9- *The French poet Jacques Prévert was born in 1900 and died in 1977.*

10- *Depicting the head of a woman, the "Chicago Picasso," as it is generally known, was Picasso's gift to the city of Chicago in 1967. Executed from a 42-inch steel model, the huge sculpture (50 feet high, 162 tons) stands in the Civic Center Plaza.*

11- *Picasso was referring to one of the countries in the (former) Eastern bloc.*

12- *Roland Penrose (1900–1984) was a British surrealist painter, promoter, and modern art collector. He was also Picasso's friend and biographer.*

13- *Picasso stayed in Céret in 1911, 1912, and 1913, where he completed a number of important Cubist works.*

14- *Jacqueline's daughter from her first marriage.*

15- *Palau i Fabre was born in 1917. He lives in Barcelona and continues to research and publish on Picasso.*

16- *Two Essays on Picasso, which came out that year.*

17- *The philologist Pompeu Fabra was born in 1868 in Barcelona and died in 1948 in Prada. He codified the rules of modern Catalan.*

18- *See Pierre Assouline's biography* L'homme de l'art: D.-H. Kahnweiler, 1884–1979 *(Gallimard, Paris, 1989). See also the catalogue for the 1984 Kahnweiler exhibition at the Georges Pompidou Center.*

19- *Kahnweiler's gallery at the time was actually called the Galerie Simon, which was located at 29 bis Rue d'Astorg from 1920 until 1940. The Galerie Kahnweiler was open from 1907 until 1914 at 28 Rue Vignon. In July 1941, to avoid the confiscation of the Galerie Simon because of the Nazi sponsored ordinances under the Vichy regime, Louise Leiris had acquired ownership of it.*

20- *Daniel-Henry Kahnweiler had asked Maître Roland Dumas to provide a legal opinion. In fact, Picasso had filed suit against his former companion Françoise Gilot after the publication of her book* Life with Picasso *(McGraw-Hill, 1964). Dumas became Picasso's lawyer and represented Jacqueline with respect to Picasso's estate. Dumas also carried out the Maestro's wishes by arranging the transfer of the famous* Guernica *from New York's Museum of Modern Art to Spain after democracy was restored in that country. The painting has hung in Madrid's Centro de Arte Reina Sofia since 1981.*

21- *Published in English as* The Four Little Girls.

22- The Corrida of Mourning. *It could also be* La corrida, *written on July 3, 1940, and appears in* Picasso: Écrits, *co-published by Gallimard and La Réunion des Musées Nationaux (1989).*

23- *Juan Gris was born in Madrid in 1887 and died in Boulogne-sur-Seine, France, in 1927.*

24- *Renato Guttuso was born in 1911 in Palermo and died in 1987 in Rome. His substantial œuvre was marked by social realism and various other influences. He and Picasso met in Paris just after the Second World War.*

25- *The great Spanish poet Rafael Alberti was born in 1902 and died in 1999 in Puerto Santa Maria, Cádiz. Several of his poems and other works were inspired by Picasso and his œuvre. Alberti left Spain at the end of the Civil War and did not return until 1977.*

26- *Joaquin Martinez de la Vega (1846-1905) was born in Almeria to Malagueños parents. He moved to Málaga in 1868 and garnered some renown for his portraits of the local bourgeoisie and for a number of publlic commissions, although he died a pauper.*

ↂ

1969

January 8

When I'm at Picasso's, I often run into people I'd lost contact with long ago. One of these people is Josep Palau i Fabre.

When I first met Palau, a mere twenty-two years ago, he was a young student in Paris. At that time, he was already known in Parisian artistic circles. Sabartés introduced him to Picasso, and I met him at the same time.

Palau has written several books on Picasso, including *Picasso in Catalonia* and *Two Essays on Picasso*. He told me he's working on another book on *Las Meninas.*[1]

For several years, Palau has been busy compiling information on Picasso. He is putting together a series of files consisting of notes, comments, and biographical data. He hopes to complete this project, which he sees as the most important task of his life. But he is not simply content to go where other researchers have gone

before. He has chosen to revisit various sources, tenaciously and rigorously, regardless of the difficulties he encounters.

Picasso's first biographer was his friend Jaime Sabartés. Jaime was first not only in chronological terms but also by the scope and importance of his work. As I see it, Palau is continuing Sabartés's work in certain ways.

Sabartés got the chance to observe Picasso at work every day for many years. At times, he served as the Maestro's confidant. In the 1950s, during a long stay in Málaga, Sabartés compiled a good deal of information on Picasso's life, which, up until that point, researchers had not yet done.

Palau works deliberately and methodically. Depending on his free time and financial resources, he visits places where Picasso once lived and worked. He interviews as many eyewitnesses as he can track down, drawing on their collective memories. When there is no one left to interview, he immerses himself in Picasso's former milieu to gain a better understanding of the artworks or period he's researching.

At times, Palau's "on-site" technique allows him to correct errors he's tracked down in some text. During

11.7.69.

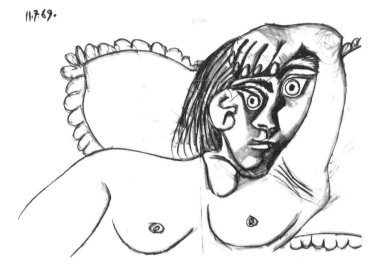

Charcoal and ink. July 11, 1969. 25.8 x 39.8 in.

one of our recent conversations, he told me that on his last trip to Málaga, he established Picasso's exact time of birth. Apparently, the time mentioned in various biographical works is incorrect.

I should point out that Palau has one advantage not enjoyed by everyone: he is able to interview the Maestro in person and to compile valuable information firsthand.

When Palau is visiting Notre-Dame-de-Vie, we all know he'll be here for several days. He checks into a room in a modest hotel in Cannes and stops by every day at precisely 5:00 p.m.

Of all the visitors to Picasso's home, Palau is about the only one who comes up by bus. He even arrives on foot sometimes. Since Mougins is about four miles from Cannes, the trip here and back adds up to a substantial walk.

Picasso's estate is near the top of a hill that's quite steep. In an age where the car is king, we city dwellers are unaccustomed to strenuous exercise. But Palau climbs the hill without difficulty. Perhaps that's why Picasso always welcomes him so warmly. When I mentioned this to the Maestro, he said, "What do you expect? Palau loves his work, and he's serious about what he does. He deserves our help."

So Picasso is helping him. The two of them are seated in the living room, which also serves as the dining room and from time to time as a studio. Palau takes his notes out of his pocket and the interview begins.

The most surprising thing about these sessions is not so much the apparent banality of Palau's questions, which may focus on the name of someone who owned a house Picasso rented almost forty or fifty years ago, but Picasso's patience and, above all, his prodigious memory.

Later that afternoon, I go into the living room and offer to drive Palau back to his hotel. Since I live in Cannes, it's no trouble for me to drop him off. I'm quite

sure he's not exactly thrilled by my offer, insofar as it's designed to cut short the interview. But of course, I am also sparing him the walk back to his hotel. What Palau may see as bad timing, however, is actually good for Picasso. If the Maestro is not disturbed by visitors, he can concentrate on the only thing that really matters to him: work.

January 9

I got to Notre-Dame-de-Vie around 3:00 p.m. and noticed that Palau was already there. Picasso is going to Vallauris, and Palau is supposed to accompany him.

After we exchanged greetings, Palau retrieved a copy of his *Doble ensayo* from his satchel and gave it to me. Jacqueline was there, and she asked him to write in a dedication for me. He did so, but instead of giving the book to me, he handed it to Picasso.

"Now it's your turn to write something," he said. Picasso took the book, smiling broadly. He wrote in a few lines and, in the blink of an eye, finished a drawing. "Another Rembrandt," he said as he handed the book to me.

Whenever Picasso gives one of his books to a friend and writes an inscription in it, he includes a small sketch.

The strange thing is that his chosen "theme" is quite consistent. Nowadays he draws the head of a man wearing a feathered hat, very much in the 17th-century style. In the postwar years, he drew doves. It's like his personal trademark—a message of friendship from Picasso to the recipient.

I thanked him. Everyone in the room examined the drawing, which featured an unusual detail. The inscription, including three capital letters (SSS, for "Su Seguro Servidor," or "Your Faithful Servant"—a very "Picassian" touch) and the signature, appeared underneath Rembrandt's head and resembled an article of clothing covering a torso. We pointed this out to Picasso. He reached for the book so he could look at the drawing. "Give it to me and I'll finish it," he said.

He put his glasses back on. As he was drawing, the whole room remained silent.

He finished and handed me back the book. Now the figure was complete: Rembrandt was standing with a palette in his left hand and, in his right, a paintbrush, which looked like a flower. And that's how I came to receive an unexpected gift from Picasso yesterday.

April 11

A few days ago Jacqueline informed me that Picasso wanted to empty out one of his studios—the large one on the ground floor, where he stores many of the paintings in his personal collection.

I've rarely had reason to enter this room. The door is kept locked, and Picasso has the key. In fact, no one is allowed to set foot in the studio without permission, and that would require some special occasion.

Given that objects, books, paintings, and pieces of furniture usually stay exactly where they are in this

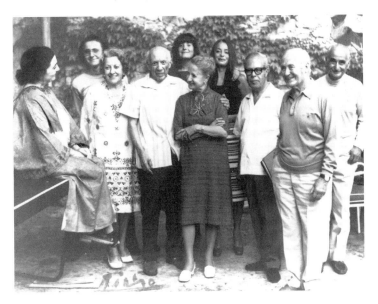

Jacqueline and Pablo Picasso receive their Spanish friends. Among them are Joan Miró and, in the background, Laenda Crommelynck and her daughter Carine. Mariano Miguel Montañés is on the far right. July 18, 1972.

house, transporting hundreds of paintings is a revolutionary act.

Despite the huge home—or, more precisely, homes—that Picasso has at his disposal, he is forever complaining that he doesn't have enough space to work in. And he's quite right. If artists have access to their past works, an entire world of memory is opened up for them, conjuring up the past and generating new sources of inspiration. No artist could get down to work if his studio were jammed with rows of canvases. Nor would he be able to consult this vast storehouse of images, which is what a collection is.

To nonspecialists, transporting a few hundred paintings from one room to another might seem like a minor undertaking as far as physical or material exertion is concerned. In fact, it's a huge chore. Remember that paintings are not always the same size. They have to be moved very carefully to avoid touching or ripping them; if several paintings are moved at the same time, this is easier said than done.

Picasso has always had a large collection of outstanding paintings, including his own and other artists' works. Canvases corresponding to various stages of his life and artistic career have been carefully selected and stored in a room that no art dealers have access to,

unless Picasso chooses to invite them in as a gesture of friendship.

In the studio I'm referring to, there is—or there was, since I'm writing this after the fact—a very important collection of paintings by Picasso and various other artists, including Henri Rousseau, Renoir, Modigliani, Matisse, and Manet. I'll stop there, because my head is starting to spin from the mention of such illustrious names!

When moving day finally arrived, Jacqueline assumed command of the "troops," which included the Crommelynck brothers, Laenda, Cathy, Jacques Bresnu (the chauffeur), and me.

I took up my assigned position by the doorway, inside the studio. My task was to group the canvases according to size and to pass them along to the other team members who were doing the actual carrying.

Of course, I tried to take in as many details of each painting as I could. Unfortunately, the clock was ticking. Ideally, we wanted to finish the job before Picasso finished his siesta, but that didn't happen. He came down around 4:30 p.m., smiling and good-humored but nervous and visibly excited. We were in the process of rearranging something that reflected his entire life. Each painting symbolized a moment in time.

"Many of these paintings are important," Picasso said, "not because they're worth a lot of money, but because they're not for sale at any price. Works like these are found in museums or in the hands of collectors who are unwilling to part with them." He pointed to two very important Rousseaus. "Those cost me five francs."

We gradually cleared out the studio. One last painting was leaning against the wall, a wonderful portrait of Jacqueline sitting in a rocking chair. Jacques swept the floor and we shut the windows. I took one last look to check if we'd forgotten anything and then locked the door behind me. Now Picasso has all the room he needs to work—in an empty studio.

April 19

In terms of atmosphere, Jacqueline's office is certainly in harmony with the other rooms in the house. Objects of all shapes and sizes have invaded all of the available space. Books, magazines, and papers are strewn throughout, covering the furniture and spilling onto the floor. However, her office does have one distinctive feature: all of the paintings and drawings on the walls are by Picasso, and they were all inspired by one person— Jacqueline.

The studio where Picasso now does his painting is separated from Jacqueline's office by a balcony or passageway that faces south. That's where Picasso places his canvases to dry. Whenever Picasso is painting, Jacqueline sets up shop in her office. If he ever needs anything, she is within earshot.

Jacqueline had to go somewhere this afternoon, so it's my turn to attend to the Maestro. I have to be there in case he needs anything, but I'm not to disturb him. I pick up a book of poetry by Prévert and begin reading.

But for some reason, I can't concentrate. The art-works in the room are holding sway, even though I know them well. A painting can't be digested in only one viewing, or even ten. Art will only reveal its secrets through habitual and frequent contact. In this office, the walls are covered with paintings and drawings, reaching into every corner. Although I'm in here every day, it's usually only for a moment, when I pop in to ask Jacqueline some question. Now I get the chance to examine everything more closely.

Now something else is preventing me from focusing on my book. Questions keep running through my head: What is Picasso doing? Is he painting? Is he all right? Does he need anything? I am aware of my responsibilities and cannot relax completely.

All of a sudden, I see Picasso put a painting out to dry on the balcony. He bends down to set it on the floor, and as he's getting up, he waves to me. I watch him walk back into his studio and immediately hear his footsteps drawing near. A moment later, he's sitting in front of me.

I asked him if he wasn't tired from working so hard, but he didn't answer my question. He said, "Imagine this: for the past few days I've been constantly humming old Spanish songs. Do you remember 'The Feast of the Dove'?" I told him I did. I started to explain, but he interrupted, "How about this one?" With a smile on his face, he looked as happy as a child at play. He began singing:

I am the first rat
And I am the second …

Before he could finish, I joined in:

And I am the third rat
And when the policemen chase us …

I know the song by heart. It was popular around the turn of the century, and I often heard my mother humming it. Picasso was amazed I'd remember such an old

tune. I was even more surprised to realize that his memory was so well stocked.

I know he has a fabulous memory. Indeed, he only forgets what he wants to forget. It's like a vast warehouse of props, scattered everywhere. Each prop will get a chance to prove its usefulness. An object or character he remembers may eventually turn up in a painting or drawing, even though its presence may seem strange and incomprehensible to us. It may be another vestige extracted by Picasso from the unlimited reserves of his memory. And it may appear distorted, disguised, or fragmented—another mystery associated with the creative process for us to ponder.

When I entered my office the following day, the first thing I noticed on the table was a small drawing that Picasso must have done the night before. It showed three rats in turn-of-the-century garb—another memento for me. I was moved and touched.

When I saw Jacqueline later on, she said, "You have no idea how happy Pablo was that you remembered the song about the rats. He kept on saying, 'Only two people in the whole world know that song: Miguel and me!'"

May 14

Picasso showed me the "Salon de Mai" exhibition catalogue that Madame Leiris brought with her from Paris. I leafed through it for a few minutes. Neither of us said a word. We were in what we alternately call the dining or living room, depending on the time of day. After his siesta, Picasso usually shuts himself up in his studio and works without interruption until dinnertime. Today was different because Madame Leiris's visit disrupted the pace of his work. I gave the catalogue back to him. Although I said nothing, he could tell I was disappointed.

Picasso contributed three paintings to the exhibition. They're very recent works, with what seem to be smoother lines than he's used in the past, primarily in shades of red. They're easy to "read," and the figures depicted in them apparently inhabit a harmonious and balanced universe. Form and content converge, highlighting the artist's powers of innovation.

The catalogue featured reproductions of all three works. Alongside them, all of the other images vanished, as if absorbed. I didn't quite know what to say to Picasso.

"Can you tell good from mediocre from absolutely rotten?" he asked. I admitted I was incapable of voicing such an opinion. All I know is this: I like certain things

and dislike certain other things, based on personal and subjective criteria. I told him, "If I see a painting and fantasize about having it in front of me every day, for the rest of my life, then I guess it's good—or at least I know I like it. That's good enough for me."

Picasso replied: "Well, I don't even know what's good and what's not. Who can ever tell an artist's creative potential, even if the work we see before us seems mediocre? There's no way I could."

I agreed with him, but I also knew he wasn't saying everything he was thinking. The truth is that Picasso always feels infinite respect for those who create, or who attempt to create, including manual laborers. Picasso rests long enough to revitalize himself before resuming his work. He is tolerant of everything—except idleness.

October 6

"Patriotism is a profoundly important reality," Picasso announced. We were sitting on a bench in the garden. Jacqueline was due back any minute with some friends she'd gone to collect in Nice.

"Do you remember the nurse who comes here to give the chauffeur's wife injections?" he asked. "Whenever I see her, I greet her more warmly than I

do many other people. You know why? Because she's from Perpignan, and she reminds me of our Spanish compatriots."

"I love Perpignan," I said.

"I prefer it to the Côte d'Azur," Picasso said. "Perpignan is more real, more genuine. When you walk around the city, it feels like you're in Spain."

I replied, "Whenever I see a car with Spanish license plates, I look at the people inside to see if they really look Spanish. If they do, my curiosity is aroused and I want to find out where they're from and where they're going. I feel like chatting with them, though I never do."

Picasso said: "Neither do I now. I'm always in the car, and I never have the opportunity or the time to take a walk. In the past, though, whenever I saw a tour bus from Barcelona or Madrid, or elsewhere in Spain, that had pulled over somewhere, I'd walk right up and chat with my compatriots."

At that moment, the doorbell rang and the gardener ran to answer it. It was Jacqueline and the guests. "You see, these people have their business to attend to. They come here thinking that because they've made an appointment in advance, all their problems will be solved."

"Like they were lined up at the bank," I replied.

"Yes, that's what they think. But the reality is quite different. You have no idea how much that annoys me."

October 11

The photographer and filmmaker Lucien Clergue, whom Picasso met in Arles a few years ago when he was going to the bullfights, is working on a film on Picasso's œuvre.

The film will be shown at various American universities. I know Clergue has done some filming at the Picasso museums in Barcelona and Antibes, in addition to the Galerie Leiris in Paris. He also filmed a number of private collections of Picasso's works. He came to Notre-Dame-de-Vie a few months ago to film a series of portraits of Jacqueline that Picasso painted at his château at Vauvenargues.[2] Clergue has obtained Picasso's permission to do some more filming at Notre-Dame-de-Vie.

"Work things out with him. I assume he'll have a crew. Keep an eye on things." Interpreting Picasso's pronouncements is always tricky. His instructions are sometimes so vague that the potential for error can be considerable. At other times, his opinions change so quickly

that he'll agree to something, only to change his mind a few minutes later.

Clergue showed up with his wife and three assistants. They set up in the huge sculpture studio. They arrived in two vehicles carrying some impressive-looking gear. Boxes and cases and all kinds of stuff. It's hard to believe that filming something as apparently simple as nonmoving objects would require so much equipment.

The setup takes a long time. They have to figure out the shots, install the lights, and run a series of tests. For a nonspecialist like me, it all seems rather strange. Finally, the camera is up and running.

It's clear that many people do not realize the importance of Picasso's sculptural œuvre. Even though I consider myself a close follower of his work, I'm amazed to see how many sculptures are in the studio. They include *Man with a Sheep*, *The Pregnant Goat*, *Girl Skipping Rope*, *Woman with Baby Carriage*, and *Mother Baboon and Baby*. Not to mention the ceramics, the polychromatic heads, the doves, the bulls, and God knows what else! There's also a series of sculptures made from painted metal plates.

First, the crew took a number of wide-angle shots, leaving the sculptures where they were. The viewers

will thus be able to enter directly into Picasso's personal realm. As they try to find their way amid apparent chaos, they'll come to discover a strange and tender world of poetic harmony, which the artist usually seeks to keep concealed, his emotions veiled, prevaricating.

Later that evening I told Clergue that it was time to end the session. Picasso was painting and could not be disturbed. To their credit, Clergue and his crew worked as discreetly and quietly as they could.

The next day they resumed filming, focusing on individual pieces. For each work, they had to calculate distances and adjust the lights. When he'd finished, Clergue said he'd like to see Picasso. Unfortunately, the Maestro gave orders not to be disturbed.

Two days later, the crew was at it again, filming ten paintings that Jacqueline chose as a representative sample of Picasso's œuvre over a relatively long period.

When the filming was over, Clergue again asked to see Picasso. It was 8:00 p.m., and Picasso and Jacqueline were sitting down, watching TV together.

Picasso said, "What? Are you still here? You should have kicked them out by now. What nerve, keeping you so late, and on a Saturday yet! I'm sure you had better things to do."

We said goodnight and wished each other a good weekend. I told Clergue that Picasso was working and didn't wish to be disturbed. I shooed them out, with me bringing up the rear.

On Monday I found out that Clergue had filmed again on Sunday afternoon. In addition, Picasso dedicated some books for him. Clergue is a lucky fellow indeed.

Undated journal entry [3]

Gaining admittance to Notre-Dame-de-Vie is no easy task. If the entrance gate is closed, visitors must ring up and announce themselves over the intercom. Invariably the reply is: "Monsieur and Madame Picasso are not in."

If the visitor seems to have some worthwhile objective and is persistent, the gatekeeper will inform me. I then go down to the gate and check out the situation. That's more or less what happened yesterday.

The visitors were two middle-aged men with a much younger woman. They'd come in a taxi that was waiting for them nearby. From a distance I could tell they were Spaniards, and judging by certain other signs, Catalans. Indeed, they were gesticulating with typically Catalonian enthusiasm. The young woman explained

to me in perfect French why they had come. "You can talk to me in either Spanish or Catalan, whichever you prefer," I said.

They started speaking all at once. After they'd decided who should do the talking, the older man said these words, or thereabouts: "We have come on behalf of the people of Horta de San Juan. I am the mayor, and my companion here is a municipal councilor. The council recently voted to make Monsieur Picasso an honorary citizen of the village, and we have brought an official letter of appointment, together with a photograph album of Horta. We'd like to meet with Monsieur Picasso and extend greetings from the entire village."

He went on to explain that Picasso had stayed in Horta on two separate occasions with his friend Manuel Pallarès. They were sure Picasso would remember everything about his stay in Horta. The mayor would have kept on, but I interrupted to say I knew exactly what he was talking about. However, since Picasso was out, I would be glad to deliver the photo album, the letter and their greetings to the Maestro.

But the residents of Horta, though Catalan by geography, tend to resemble the Aragonians in their stubbornness. They said they absolutely had to see

Picasso. They had been sent on a mission by the entire village. They wanted to know when they could return, how I might help them, etc. I asked them to call the following day at 5:00 p.m. After making a few vague promises, I finally got rid of them. I was sure Picasso would never agree to meet with them.

But the Maestro is always full of surprises. Today, at lunchtime, Jacqueline called me at the Villa Californie.[4] Picasso wanted to know when the Spaniards were supposed to arrive; in any event, he was willing to see them at five o'clock.

Luckily, I was quite sure they'd be staying at the Pallarès's usual hotel. I called them there on the phone to relay the good news. They rang the doorbell at exactly five o'clock.

They were visibly moved. I showed them into the combination living/dining room where Picasso receives visitors. They told me that this was a historic day for them. They couldn't stop telling me how grateful they were, thinking that I'd somehow used my influence to get Picasso to meet with them.

The discussion was very pleasant. Despite the passage of so many years, Picasso still remembers Horta and the people he met there. "I learned a lot in Horta," he

said. "Like how to load a mule and sleep in a cave. And many other things."

The mayor told us that his mother often mentioned Picasso's stay in Horta. "She told us that sometimes at lunch, an old beggar would come by looking for money. Picasso would get up from the table, stick a piece of meat between two slices of bread and give it to him. Another time a group of youngsters from the village wanted to play a trick on Picasso. They surrounded him and brandished knives, as if to attack him. Undaunted, Picasso took out his pistol. When he realized they were only fooling around, he told them, 'I don't stand for jokes like that.' "

Picasso remembered that and other stories perfectly. He described various places he'd seen and people he'd met. The mayor added, "The villagers still remember every single detail of your stay. Although it was almost seventy years ago, the older folks made sure to discuss your visit at length with their children. We assure you, their memories of you are still fresh, as if you'd been there just a few months ago." He continued, "Everyone in the village is proud that Señor Picasso once stayed in Horta. But the older generation will soon disappear, and one day people might wonder if Señor Picasso's trip really happened or if it was just a myth."

I interrupted to say that Sabartés and Palau i Fabre have both documented Picasso's stay in Horta. Nobody could question an episode described in detail by two of the Maestro's most prestigious biographers.

But different people see things differently. The delegates from Horta had a job to do, and they wanted to ensure that their mission was a successful one, no matter what.

"In the village we have a relic of Saint John," said the mayor. "We plan to display it inside the council chambers. And we'd like to show the whole world that you made two trips to Horta. So we'd need you to put something in writing, perhaps a letter. We could place it next to the relic of Saint John, in the display case."

Picasso was highly amused at this: "A few years from now, perhaps they'll think I was the saint!" He said he'd consider their request, although he couldn't promise anything definite, and so forth.

The interview would have ended at that point if Jacqueline hadn't noticed the camera slung across the councilor's shoulder. She suggested that they pose for photographs, and she ended up taking a few shots. (Jacqueline is an excellent photographer.)

The visitors were delighted. Picasso and Jacqueline walked them back down to the entrance gate. Erring on

the side of discretion, I said goodbye at the front door. A little while later I watched as Picasso and Jacqueline strolled back up the hill, arm in arm.

When we were alone, I said to Jacqueline, "Pablo seemed happy." "He was," she replied, "but he was somewhat disappointed. Pablo still pictures them in their traditional dark-colored clothes, with their underpants sticking out and their handkerchiefs tied around their heads!"

1- *In late 1957 Picasso finished an important series of oil paintings inspired by Diego Velásquez's* Las Meninas *(1656), which are on display in Madrid's Prado Museum. The* Meninas—*the Spanish royal family's maids of honor—are depicted along with the Infant Margarita and other Court figures.*
2- *A village near Aix-en-Provence (north of Marseille), roughly 100 miles from Cannes.*
3- *Judging by the manuscript paper and ink, this entry must date from 1969.*
4- *The Villa Californie is located in the district of the same name in Cannes. Picasso lived there from 1955 until 1961.*

1970

July 15

Werner Spies is a young German photographer who's completing a book about Picasso's sculptural œuvre.[1] He came recommended by Louise Leiris, who introduced us at the opening of the Avignon exhibition, which the late Yvonne Zervos conceived.[2] For a little over an hour, Picasso answered all of the photographer's questions. Picasso has a prodigious memory, and remembers every single detail: locations, materials, and the sources of his inspiration from long ago.

Picasso said to me, "Show him around the sculpture studio." I knew Picasso had had enough and felt a powerful urge to get back to work. Spies was delighted. He realized how privileged he was to be able to stroll around Picasso's studio, camera in hand.

I am quite familiar with all of Picasso's sculptures. I've seen many of them at exhibitions and all of them in photographs. But the most extraordinary thing for me is

seeing the originals. This is particularly important with Picasso's sculptures, because it's possible to identify the different materials he used.

Spies took some photos, and we rejoined Picasso in his studio upstairs. "Sculpture," said Picasso, " is always a delicate and fragile art. The *Venus de Milo* is missing her arms, but if anyone ever found them, they'd simply reattach them, and the problem would be solved." He continued, "But if the arms went missing from one of my sculptures, who'd reattach them? How would you tell the arms from the legs? I'm the only one who could. So when I'm no longer here …"

That day Spies took a good many photographs.

August 10

Mr. H. runs an important gallery in London. He stopped by to show the Maestro a number of original Picassos he intends to purchase. He wanted Picasso to verify their authenticity before he finalizes the deal with the vendor.

I met with him in what we call Jacqueline's little house, a large room in one of the buildings adjoining Notre-Dame-de-Vie that Jacqueline uses as a place of refuge and where she can entertain guests without

disturbing the Maestro. The room contains a number of antique furnishings. There are several portraits of Jacqueline, all painted at Vauvenargues, and numerous books. The atmosphere is welcoming and intimate.

Mr. H. arrived with five "originals" and a photo of another work, all dating from the early 1900s and all quite small. He told me the works came from Barcelona and had been sold by an acquaintance of Picasso's a few years ago.

It was 11:30 a.m., and Picasso was still in bed. I went up to his room to show him the works. He looked at them and exclaimed, "Forgeries!" He took out a ballpoint pen and carefully crossed out each signature. He then wrote "forgery" on each painting. They are now worthless and will have to be withdrawn from commercial circulation.

There must be hundreds, if not thousands, of fake Picassos in museums and private collections. Judging by the examples that show up at Notre-Dame-de-Vie, the number must be very high. Cheats, forgers, and rip-off artists use a variety of techniques. In some cases the quality of their work can fool the experts.

Works by the great masters, from the Impressionists to Picasso, command high prices. This sometimes prompts certain failed—and unscrupulous—painters to try their hand at copies or imitations. These forgeries

eventually end up in the U.S. or major European markets, including England, Switzerland, Germany, France, and Scandinavia—through independent channels.

As I mentioned, forgers use a wide variety of techniques. Producing highly accurate copies of works by well-known artists is always a risky business. In fact, such artworks are always carefully catalogued, and their owners, whether museums or collectors, are clearly identified. In that case, forgers attempt something similar, generally a smaller copy resembling a preliminary or rough draft that predates the final work.

One common trick is to produce a painting or drawing that is not based on a particular well-known work but that nonetheless mimics an artist's style—and bears his signature, of course. If the forgery is a skillful one, it may fool the experts, who often believe that an unknown work by Artist X has somehow appeared out of thin air.

Another relatively common trick involves passing off reproductions as originals. That generally applies to drawings, prints, or lithographs. Non-experts frequently have difficulty distinguishing between etchings with limited print runs, which are produced using plates engraved by the artist, and mechanical reproductions, thousands of copies of which may be available.

At times, forgers focus on touching up reproductions.

Inexperienced buyers sometimes come in contact with reproductions of a work they're already familiar with. If they can actually feel the ink on the paper, they may be persuaded that they're holding an original.

I'm reminded of Madame M., who owns Gallery A. Not so long ago, she stopped by to show Picasso what she was convinced was one of the preliminary sketches he'd made for his famous sculpture *Man with a Sheep*. Picasso told her right away that it was a forgery. When she protested, he showed her the original sketch. In fact, the forgery was based on a photograph and was smaller than the original. The reproduction had been touched up very skillfully, and Madame H. had purchased it a short while ago.

People taken in by forgeries are clearly victims of their own greed. More than one sinner has succumbed to the temptation of purchasing a work by a great master at far below market prices.

Forgers spend a lot of time imitating signatures. Artists' signatures change over time, and adult script is different from adolescent handwriting. Since artists are creators par excellence, the evolution of their handwriting is no doubt even more pronounced. Picasso's various signatures have been reproduced and are accessible to

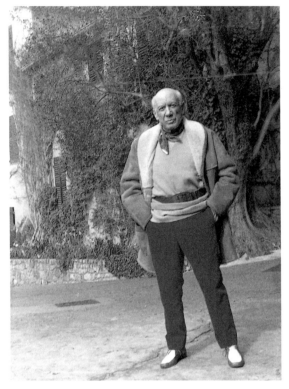

Pablo Picasso in Mougins in 1970.

anyone curious enough to examine them.

We should not forget another trick: tracings. Tracing a reproduction of a drawing could generate an "original" that will be accepted as such by certain auctioneers.

To enhance the credibility of their "originals," forgers have been known to come up with fantastic-sounding stories to account for works that are unknown to experts

or collectors. In one case, an individual inherited a forgery from a relative who'd bought it years ago at a flea market in Paris or Barcelona.

In recent years a number of fake Picassos, no doubt produced in Spain, have emerged, along with certificates of authenticity signed by Picasso's old friend and former secretary, Jaime Sabartés. Anyone who knew Sabartés well—as I did for many years—knows that he would never have agreed to authenticate any of Picasso's works. Why would he run the risk of being wrong when all he had to do was ask the Maestro? Any Picasso "certified" by Sabartés is a guaranteed fake.

As a result, experts have to proceed very carefully—and the best experts to consult are the artists themselves. Of course, that's only possible if they're still alive. And after their death …

August 22

Piero and Laenda Crommelynck and their daughter Carine came to lunch today at Notre-Dame-de-Vie. It was "Papa" Piero's birthday, and Jacqueline gave him several ties—big, wide, brightly colored ties. They're all the rage nowadays, and you can see them on display in boutiques in Cannes, both on the Boulevard de La

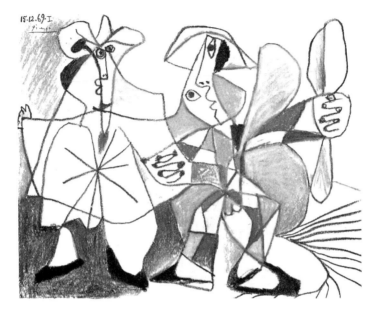

Color chalk.
December 15, 1969. 12.8 x 16.1 in.

Croisette and the Rue d'Antibes.

Piero was wearing a green shirt and fancy, brightly colored pants. In a show of gratitude, he tied one tie in the customary position around his neck, and two others around each arm, just above the elbow. "As you can see," said Picasso, "one of the great things about fashion today is that people can dress any way they please."

"That's right," I replied. "You see it all nowadays.

Really short skirts and really long ones. And women are setting the trend. There's all this talk about fashion styles, but people are really doing what they please. There's a good deal of freedom."

Picasso gazed at me for a few moments and replied slowly, as if thinking aloud, "There's never enough freedom ..."

1- *Spies's book, entitled* Sculpture by Picasso, *was published in 1971. As director of the Musée National d'Art Moderne, Centre de Création Industrielle in Paris, Spies, an art historian, conceived and curated the magnificent exhibition,* Picasso sculpteur, *at the Centre Georges Pompidou in 2000.*
2- *Yvonne Zervos died a few months before the exhibition opened. The exhibition ran from May through October 1970 in Avignon's Palais des Papes. Her husband, Christian Zervos, who had prepared the catalogue, survived her for only a few months.*

∞

1972

March 18

We were chatting away about various topics. Picasso suddenly fell silent and began staring at a bouquet of flowers Jacqueline had placed on the table. "Look at that," he said. "Do you see that rose? Well, I can clearly see a face in it. The nose, the eyes, the mouth, everything, even the ears. Nature is so wonderful."

I sat down next to him as he tried to get me to visualize what he saw. Amid the rose petals, I attempted to pick out the human face that existed in Picasso's artistic imagination. He must have known that despite my best intentions, I was unable to see what he saw. He pulled away slightly and said, as if to himself, "If the petals of a flower can suggest a human face, how many things can a face suggest?"

April 28

I heard Picasso's footsteps and there he was, standing in front of me, smiling. He held out his hand in greeting: "How are you?" It was almost noon, and he'd just gotten up. As he does every morning, he spent an hour or two in bed, reading the newspapers and going through his mail.

I told him that William Rubin, chief curator of New York's Museum of Modern Art, had called. Picasso had to sign a customs document authorizing the export of one of his sculptures. The company handling the transportation arrangements was supposed to contact us. "Fine," he said. "We'll take care of all that. The most annoying thing is that I never have enough time to do anything. Even if I get up at 5:00 a.m., it's the same old story. There's always something that stops me from getting down to work."

I told him I'd seen six of his drawings this morning, inscribed with yesterday's date. I said they looked quite good. "Oh, right. The six heads. I thought I'd put them away in a folder. Glad you liked them. What are they supposed to be? At any rate, they mean nothing to me."

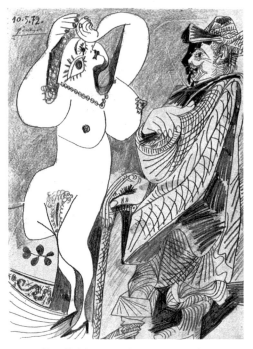

Pencil. May 10, 1972. 13.7 x 10.6 in.

July 26

One day in March, Picasso told me that he wasn't born in Place de la Merced, as is generally believed. Picasso started reminiscing: "When my father was transferred from Málaga to La Coruña, my family decided to move by boat.[1] In fact, our decision was driven by a crucial consideration. A relative who worked at the customs house was able to get us discount fare tickets. So it

was price, not any yearning for maritime adventure, that proved to be the deciding factor. In those days, traveling by boat was slow and arduous. When the vessel stopped in Vigo, my parents decided to complete the journey by train. When we arrived at the station in La Coruña, my father left us in charge of the baggage while he went off to find a vehicle to take us to the inn. It turned out to be a cart, drawn by a pair of oxen. So that was how we arrived at the inn. And in those days, the train station was quite a ways out of town."

I told Picasso I didn't recall having read about the "oxcart incident" in any of his biographies. "Of course not," he replied. "Although I did tell the story to Sabartés on several occasions. He was always very careful to 'clean up' everything that was published about me. He must have found the oxcart unworthy of my 'greatness.' I'll give you an example of Sabartés's valiant efforts to filter out and cover up things he considered unworthy. You're aware that Sabartés mentioned my uncle, General Picasso—the one who issued that infamous report on certain unpleasant aspects of Spain's intervention in Morocco. And you know he also mentioned various ancestors of mine who were in the clergy, etc. Well, he never said a thing about an uncle of mine,

a barrel maker by trade, who lived in Málaga. This uncle once built me a bathtub. It really meant a lot to me. But he would have seen it as insignificant, since for him, making barrels or making bathtubs would have been much the same thing."

August 26

The phone rang. It was Louis Aragon[2] calling for Picasso. "It might be someone pretending to be Aragon," Picasso said. "Find out whether it's really him." I told the caller that Picasso had gone out for a

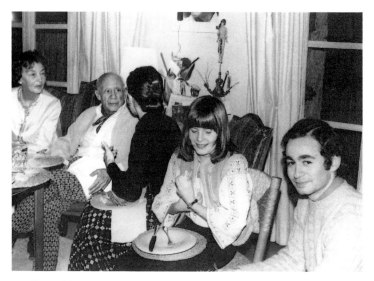

Pablo Picasso and friends. Front right is Alberto Miguel Montañés, Mariano's son. December 31, 1970.

walk around the grounds. Aragon said he was in Toulon. He was hoping to visit Notre-Dame-de-Vie and see Picasso. He left his phone number. A few moments later, I called him back to say that Picasso would see him on Saturday at 5:00 p.m.

Picasso told me, "I met Aragon at the end of the First World War. He was almost finished with his medical studies, and he'd been mobilized as a doctor. Guillaume Apollinaire was also in a medical unit."

Picasso and Aragon last saw each other seventeen years ago. I remember meeting Aragon on many occasions in Picasso's studio on the Rue des Grands-Augustins in the period after the Second World War. In those days, Paul Eluard and Jacques Prévert were also regulars. I don't know why Picasso and Aragon fell out of touch. Picasso must know, though he's too tactful to say anything.

Aragon arrived on Saturday at the appointed time, accompanied by a young man with a beard. Aragon has aged a lot. His hair was completely white and long, reaching down to his shoulders. His white suit, including a pair of baggy pants, was by some famous designer. Picasso told me that Aragon still had the same look in his eye but that his overall appearance had changed a great

deal. All we were told about the young man was that his name was Alain and that he hadn't done his military service because he's a conscientious objector.

Aragon told us that they'd gone to see Jean-Louis Barrault, who is supposed to present a stage adaptation of Aragon's poem "Le Fou d'Elsa" next season. Alain, his young companion, is responsible for the adaptation.

Picasso praised Aragon's recent book on Matisse. Picasso owns several paintings by Matisse, including a still life that was reproduced in Aragon's book. "It's one of Matisse's most beautiful works," Picasso said. "But a strange thing happens: at times, the painting seems extraordinary, whereas at other times, I like it much less."

Jacqueline pointed out that we shouldn't always take Picasso's statements literally. Sometimes they're just trial balloons meant to gauge his audience's reaction.

The conversation kept lapsing into banalities. It was apparent that the two friends were having difficulty renewing the old camaraderie they'd shared for so many years. But Picasso's conception of friendship is too elevated for him to tolerate out-of-character behavior. He suddenly stood up, looked his old friend in the eye and said, "Aragon, I know I have something to say to you,

but I can't find the right words. What about you? Don't you have something to say to me? Just say it, even if it's just one word."

Yet neither man could utter this mysterious word, whatever it may have been. We all continued talking, desperate to fill the void. But when Aragon and young Alain left Notre-Dame-de-Vie a little while later, the word—a spark that might have rekindled a friendship—remained unspoken.[3]

September 9

"What's new?" Picasso stopped by to see me in the room where I work, which is known as "Mig's office." Twice a day, before he has lunch and after he's had his siesta, I hear his footsteps approaching, and there he is, standing before me.

"What's new? Not much, just a few phone calls."

"What about the Leirises?"

The Leirises arrived in Cannes yesterday. Jacqueline went off to run a few errands and to pick the couple up at their hotel. They're due back soon.

We talked about Picasso's son Paulo, who stopped by yesterday. Picasso obviously made some logical connection, because he asked, "Have you seen the portrait

of Paulo's mother? The Leirises had it restored, together with a painting from the Blue Period. Come and take a look."

He was referring to the famous portrait of Olga wearing a white lace mantilla. The painting is highly academic in its construction. The artist obviously sought to render every single detail with enormous care. "It's a little *pompier*," said Picasso, "but that's how she wanted it."[4]

"Is it from 1917?"

"Yes, it is. I painted it in a hotel on the Paseo de Colón. I'm sure you walked past it a thousand times." My family moved to Barcelona in 1917, when I was six.

Olga's portrait is part of Picasso's personal collection. I've seen it on two or three occasions. It's also been reproduced numerous times.

Another painting, entirely in shades of blue, depicted a young woman who was apparently asleep. "Is that one from 1901 or 1902?" I asked.

"It must be from 1903. She died during an abortion at San Pablo hospital in Barcelona." Picasso often went to visit his friend Cinto Reventós, a medical doctor and the brother of Ramón Reventós, the writer.

That would have been during his Blue Period. When he was 20, Picasso learned all about suffering,

poverty, illness, beggars—and prostitutes.

We continued chatting for a while. Suddenly a worried look came over his face, as if he were searching for something. I knew exactly what that signified. I touched him lightly on the arm and said, "I'll see you in a bit." And I returned to "Mig's office."

Novenber 9

I was having tea with Picasso when I began coughing so violently that I had to get up and leave the room.

Picasso hasn't been feeling well for a few days now.

November 10

I didn't go to Notre-Dame-de-Vie this afternoon. I had a fever, and I went back to bed. In the evening my temperature was over 102°F.

November 16

I've taken up my normal duties again, but so far I've seen almost nothing of Picasso. I was worried I might give him my cold, so I didn't have tea with him again until today.

Jacqueline asked me not to talk too much with him because he's tired.

November 17

Picasso didn't look like he was doing too well today. Once again, Jacqueline asked me to make sure that he didn't get all worked up when he was speaking. I ended up giving monosyllabic answers to his questions. Once we'd drunk our tea and eaten our toast, I left him to his own devices.

November 18

The Gilis stopped by at 6:00 p.m. Picasso and I had tea together just before they arrived, and he dedicated an English translation of a book, *The Birth of a Genius*,[5] which he had provided illustrations for, to me. As he was presenting it to me, he paid me a number of compliments.

November 24

Picasso has been confined to bed for the past few days. As in the past, the problem seems to be liver-related. It doesn't appear to be particularly serious, but this

evening he had a brief fainting spell, which alarmed us all. Jacqueline, the doctor, and a nurse spent the night at his bedside.

December 2

Picasso has been feeling better. For a few days there, he had us quite worried. Around 6:00 p.m., he sat up a little in bed and drank some tea. Jacqueline asked me to stop up and say hello.

"Is Miguel there?" he asked.

"Of course," said Jacqueline.

I shook his hand. He gazed at me and said, "I've been stuck in this bed for the past few days. It must be serious."

"You just have a fever," I replied. "It could happen to anyone."

Nineteen seventy-two

1- *La Coruña is a city on the Atlantic coast, in northwestern Spain.*

2- *Louis Aragon (1897-1982), famous French poet and novelist.*

3- *Aragon's visit to Notre-Dame-de-Vie and Picasso's challenge to the poet may seem somewhat mysterious. Picasso had joined the French Communist Party (PCF) on October 4, 1944, and subsequently distanced himself from the party (see* Picasso: The Real Family Story, *op. cit.). Picasso's controversial charcoal portrait of Stalin, which was commissioned by Aragon and appeared on the front page of the PCF's cultural journal (*Les Lettres Françaises*) upon Stalin's death in March 1953, touched off a furious polemic in Communist and Soviet circles. Apparently, it was too far removed from the tenets of socialist realism! As a result, Aragon wrote a vile letter that was brutally and acerbically critical of Picasso. Although my father knew about the incident with the Communist establishment, I am not sure if he ever was aware of Aragon's letter.*

4- *The French term* pompier *("pretentious") was coined in the 19th century to designate an academic (and pretentious) style of painting that stood in stark contrast with new art forms such as Impressionism*

5- *This work was originally published in Spanish as* El Nacimiento de un Genio. *It was written by Juan Eduardo Cirlot and featured pieces from Picasso's youth.*

1973

January 31

After the siesta, Picasso and Jacqueline went for a drive. When they got back, Picasso stopped by my office. He now starts choking if he exerts himself even a little.

We chatted for a while. I then read him a review of the exhibition at the Galerie Leiris.[1] The piece was very complimentary, and Picasso was pleased. Although he's 91, he still second-guesses himself as if he were a novice artist.

It was teatime. Picasso wanted to wash his hands before going down to the dining room. I accompanied him, holding his arm, only to realize that he was having difficulty breathing. He sat down for a few seconds. Almost immediately, he indicated that he wanted to get up.

We took a few more steps, with me still holding onto his arm. He was still having trouble catching his breath,

and he grabbed onto me for a moment. He would have fallen if I hadn't caught him and held him up.

I called out, and Jacqueline and the chauffeur came running. We laid him down on a couch. Jacqueline gave him one of his special lozenges prescribed for such occasions. She then dabbed some eau de cologne on his temples and hands, and he quickly recovered.

February 1

I got a chance to speak with Dr. Stéhelin for a few moments, and I asked him what exactly had happened to Picasso yesterday.

"Circulatory problems. If the circulation in the brain is affected, he gets fainting spells."

I asked the doctor if the attacks might prove fatal.

"Unfortunately, they might," he replied. "It could be tomorrow, or in a month, or a year from now.[2] The good thing is that Picasso is still fully aware of what's going on. And he seems extraordinarily serene."

He gave a little smile and said, "As only a Spaniard can be!"

1- *The exhibition,* 156 Recent Engravings, *ran from January 24 through February 24, 1973. Most of the engravings were produced in 1970 and 1971.*
2- *Picasso actually died two months later, on April 8, 1973.*

Correspondence

Letter from Celia Miguel Montañés to her son Alberto

Cannes, Villa Californie, Sunday, April 8, 1973

Sunday 8

It's 6:30 p.m. What a sad day this has been. I'm sure you've heard the news on the radio by now. Picasso has passed away. It's hard to believe. It seemed he'd live forever. I'm heartbroken and all alone. I hope he'll be buried at Notre-Dame-de-Vie. I haven't seen Papa since this morning, though he did call a little while ago. He doesn't know when he'll be back. I went down to notify the caretakers because he doesn't have a key.

Monday 9

8:15 a.m. Papa still hasn't returned yet. I think he'll call later this morning. No doubt he's dealing with numerous problems. If I could, I'd really like to help in some way.

I've been listening to the radio and watching the TV news. The tributes have been pouring in, though they pale in comparison with Picasso's genius.

Where will he be buried? Maybe Paris? I hope it'll be on the grounds of his estate, as Jean Cassou implied on the radio

this morning. Unless, of course, his children are opposed to the idea. Papa called me at ten o'clock and told me he'd definitely be home for lunch, though I'm not quite so sure.

Then you called. I was very glad to hear your voice, and our brief conversation was heartening. Yesterday I felt like a caged animal. I went into the studio, with the windows wide open. I walked around the room for half an hour. His tubes of paint and paintbrushes were staring me in the face—reminders of the many long hours he spent here creating. He painted Las Meninas *here, together with many other paintings I'm unaware of.*

2:10 p.m. Papa called. He'll be here around four o'clock to shower, shave, and grab a bite to eat. It's cool and rainy today, so I plugged in the electric heater. Let's hope he gets here okay.

Papa stopped by. He took a shower, shaved, and ate. Since he hasn't slept, he's going to try to rest here for a little while if he can.

Love from your Maman

P.S. Papa was going to write you a note, but he didn't have time. He asked me to send his love.
P.P.S. It turns out the funeral won't be in Paris.

Letter from Alberto Miguel Montañés to his parents

Asnières, April 11, 1973

Picasso is no longer with us. Maman's letter was very sad. I heard the news at 6:30 Monday morning when I was coming back from Damville to Paris. For the entire trip I kept think-ing of how sad and unexpected it was. I try to fathom the pain that Jacqueline and you and everyone else must be feeling. Papa must have had some agonizing moments too, I imagine. I wish I could have been there for you.

Picasso will be buried at Vauvenargues. According to the press, Jacqueline is going to move there. Is it true? What about the two of you?

Letters from Mariano Miguel Montañés to his son Alberto, following the death of Pablo Picasso

Sunday, April 15, 1973 (Villa Californie, Cannes)

As you may well imagine, I'm nowhere near having recov-ered from this terrible shock. Picasso passed away a week ago today, although time has lost its meaning. We spent two nights

watching over him. The phone wouldn't stop ringing, and the house was surrounded by dozens if not hundreds of journalists and onlookers. The police had to provide security services.

On Tuesday, just before 6:00 a.m., we set off for Vauvenargues. Jacqueline rode alone in the hearse, while we— Paulo, Maman, Arias, two of Picasso's nephews, and me— brought up the rear in the Lincoln. The driving conditions were very bad. As we were setting off, it was raining. It began to snow when we got up into the mountains. On one steep stretch, a truck was stuck in the snow. Despite our best efforts, we couldn't clear a path, and the snow was already up to our knees. There were six vehicles altogether. It was scary having to turn around, since the road was so narrow and icy.

The coffin was placed in the guards' room at the château and it remained there. Jacqueline insisted on staying. It was terrible to watch.

Maman spent the last night at Notre-Dame-de-Vie, and we both watched over him, together with Jacqueline and Jacqueline's daughter. She also accompanied us to Vauvenargues.

Picasso is to be buried on the grounds of the Château at Vauvenargues, across from the main entrance. The service is set for early tomorrow morning. The Antébis [1] are supposed to pick me up at 6:00 a.m. It will be restricted to a very few intimate friends. Picasso's relatives from Spain won't even be there, not even for the burial.

I don't remember if I mentioned that Jacqueline asked me to stay on. "What would I do all by myself?" she asked me. In the past few days we've gone over a few things. Did you look into the donation to the Louvre?

Sunday, April 22, 1973 (Villa Californie, Cannes)

This is a completely new situation I'm dealing with. I don't even know where we're headed. Jacqueline asked me again to stay with her "forever." Right now she doesn't have the foggiest idea what she's going to do.

Picasso was buried last Tuesday at Vauvenargues. Jacqueline stayed with the coffin for six days and six nights. Some of the scenes of grieving are impossible to describe. Jacqueline, Arias, and I were present for his final hours—there were only a few close friends and acquaintances there. With the assistance of some people from the Village, we served as the pallbearers. He was buried across from the staircase leading to the main entrance. We all left together, except Jacqueline, who remained alone at Vauvenargues for the entire week.

I went to see her yesterday, accompanied by the Antébis. She's very sad and doesn't want to see anyone. People have been calling and writing to offer their condolences or wanting to visit. Until now she has refused to see anyone except her closest friends.

I'm sure you heard about the works Picasso's heirs donated to the Louvre. There were a number of very important artists: Matisse, Renoir, Rousseau, Degas, Miró, and others.

It's so difficult for me to get used to the idea that Picasso is no longer with us. Notre-Dame-de-Vie is silent and empty. Jacqueline has been putting off her return as long as she can. I've been taking care of things here—lots of mail and phone calls.

As you can tell, this isn't the cheeriest letter I've ever written.

1- *Armand Antébi was the family's attorney.*

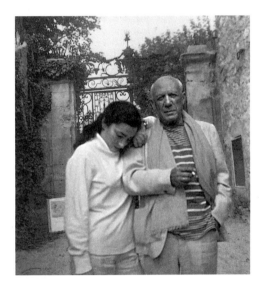

Poem to Pablo Picasso

Pablo, Forever

Here I am, in Paris.
I had to leave Mougins
Because there was nothing I could do
Not for her, not for you.
Now, a high wall
So very high
Stops me from coming close to
The woman with the torch
Who is mounting the guard
Across from the château.
That is why I am here
With your hand of bronze
Upon the table.
And, on the wall, your ceramics,
The bullfighting and the still life.
In the library, books
So many books
That speak your name to me.
As you can see, now
I live on memories,
For memories may sustain us
Even though it's only half a life.

Mariano Miguel Montañés
Asnières, February 1978

Acknowledgements

First, I would like to thank Maya Widmaier Picasso, who held my father in the highest regard, in a show of mutual respect. I am grateful to her son Olivier for his advice and encouragement, and am particularly appreciative of the impetus he provided with respect to my decision to publish the Journal.

Roland Dumas and I occasionally reminisce about the era described in the Journal, with a tinge of nostalgia. Roland was consistently supportive of my efforts throughout the project.

Although I have never met the photographer David Douglas Duncan, I have admired his books on Picasso ever since I was a child. I salute his enthusiasm, which knows no bounds.

My thanks also go to Laurence Madeline, curator of the Picasso Museum in Paris, who welcomed me warmly and provided access to dozens of letters from my father to Picasso.

I am further grateful to Prosper and Martine Assouline for the keen interest they showed in the project. I would like to pay tribute to their tremendous efforts, as well as those of their colleagues.

Acknowledgements

My thoughts today are with my father and mother, with Pablo and Jacqueline, and with our very close friend Jaime Sabartés.

I cannot possibly acknowledge everyone I met at Notre-Dame-de-Vie, although Jacqueline's daughter Cathy does deserve special mention. We were all so young then, and life was joyful.

My father certainly never anticipated that his Journal would be published. Why did he keep it, and for whom was he writing? I cannot say for sure. Perhaps he had an intuition that his Journal might possibly come to light some day. Consequently, he would be glad to know that his grandchildren—my children Cécile and Romain—count themselves among his readers today.

I am especially grateful to my wife, Annie-France, for her loving patience.

Photographic credits
End papers: © Private collection. Page 19: © Edward Quinn.
Page 25: © Private collection. Page 37: © Private collection,
La Colombe d'Or. Page 45: © Private collection. Page 63:
© Private collection. Page 71: © Raph Gatti. Page 87:
© Succession Picasso, 2004. Page 91: © Private collection.
Page 115: © Private collection. Page 117: © Succession Picasso,
2004. Page 121: © Succession Picasso, 2004. Page 123:
© Private collection. Page 140: © Private collection. Page 141:
© Private collection.
Publisher's note: Every possible effort has been made to identify
legal claimants; any errors or omissions brought to the publisher's
attention will be corrected in subsequent editions.

Olin College of Engineering
Library
1000 Olin Way
Needham, MA 02492-1200